ON THE LAWS OF JAPANESE PAINTING

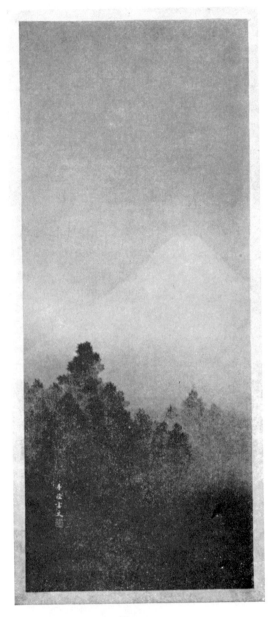

FUJIYAMA
BY MURATA TANRYU
Frontispiece. Plate 1

ON THE LAWS OF

JAPANESE PAINTING

AN INTRODUCTION
TO THE STUDY OF THE ART OF JAPAN

By HENRY P. BOWIE

WITH PREFATORY REMARKS BY IWAYA SAZANAMI
AND HIRAI KINZA

ILLUSTRATED

DOVER PUBLICATIONS, INC.

Published in Canada by General Publishing Com-
pany, Ltd., 30 Lesmill Road, Don Mills, Toronto,
Ontario.
Published in the United Kingdom by Constable
and Company, Ltd., 10 Orange Street, London WC 2.

This Dover edition, first published in 1952, is an
unabridged republication of the work originally
published by P. Elder and Company, San Francisco,
in 1911.

Standard Book Number: 486-20030-2
Library of Congress Catalog Card Number: 52-9794

Manufactured in the United States of America
Dover Publications, Inc.
180 Varick Street
New York, N.Y. 10014

DEDICATED TO THE MEMORY OF KUBOTA BEISEN
A GREAT ARTIST AND A KINDLY MAN, WHOSE
HAPPINESS WAS IN HELPING OTHERS AND WHOSE
• TRIUMPHANT CAREER HAS SHED ENDURING •
LUSTRE UPON THE ART OF JAPANESE PAINTING

Introduction

*F*IRST *of all, I should state that in the year 1909 I accompanied the Honorable Japanese Commercial Commissioners in their visit to the various American capitals and other cities of the United States, where we were met with the heartiest welcome, and for which we all felt the most profound gratitude. We were all so happy, but I was especially so; indeed, it would be impossible to be more happy than I felt, and particularly was this true of one day, namely, the twenty-seventh of November of the year named, when Henry P. Bowie, Esq., invited us to his residence in San Mateo, where we found erected by him a Memorial Gate to commemorate our victories in the Japanese-Russian War; and its dedication had been reserved for this day of our visit. Suspended above the portals was a bronze tablet inscribed with letters written by my late father, Ichi Roku. The evening of that same day we were invited by our host to a reception extended to us in San Francisco by the Japan Society of America, where I had the honor of delivering a short address on Japanese folk-lore. In adjoining halls was exhibited a large collection of Japanese writings and paintings, the latter chiefly the work of the artist, Kubota Beisen, while the writings were from the brush of my deceased father, between whom and Mr. Bowie there existed the relations of the warmest friendship and mutual esteem.*

Two years or more have passed and I am now in receipt of information from Mr. Shimada Sekko that Mr. Bowie is about to publish a work upon the laws of Japanese painting and I am requested to write a preface to the same. I am well aware how unfitted I am for such an undertaking, but in view of all I have here related I feel I am not permitted to refuse.

Indeed, it seems to me that the art of our country has for many years past been introduced to the public of Europe and America in all sorts of ways, and hundreds of books about Japanese art have appeared in several foreign languages; but I have been privately alarmed for the reason that a great many such books contain either superficial observations made during sightseeing sojourns of six months or a year in our country or are but hasty commentaries, compilations, extracts or references, chosen here and there from other

[v]

Introduction

volumes. *All work of this kind must be considered extremely super-ficial. But Mr. Bowie has resided many years in Japan. He thoroughly understands our institutions and national life; he is accustomed to our ways, and is fully conversant with our language and literature, and he understands both our arts of writing and painting. Indeed, I feel he knows about such matters more than many of my own countrymen; added to this, his taste is instinctively well adapted to the Oriental atmosphere of thought and is in har-mony with Japanese ideals. And it is he who is the author of the present volume. To others a labor of the kind would be very great; to Mr. Bowie it is a work of no such difficulty, and it must surely prove a source of priceless instruction not only to Europeans and Americans, but to my own countrymen, who will learn not a little from it. Ah, how fortunate do we feel it to be that such a book will appear in lands so far removed from our native shores. Now that I learn that Mr. Bowie has written this book the happiness of two years ago is again renewed, and from this far-off country I offer him my warmest congratulations, with the confident hope that his work will prove fruitfully effective.*

<div align="right">

IWAYA SHO HA,
TOKYO, JAPAN,
AUGUST 17, 1911.

</div>

This is a translation from the original manuscript of IWAYA SHO HA, or Iwaya Sazanami, one of the most widely known and popular writers on Japanese folk-lore.

Introduction

SEVENTEEN years ago, at a time when China and Japan were crossing swords, Mr. Henry P. Bowie came to me in Kyoto requesting that I instruct him in the Japanese language and in the Chinese written characters. I consented and began his instruction. I was soon astonished by his extraordinary progress and could hardly believe his language and writing were not those of a native Japanese. As for the Chinese written characters, we learn them only to know their meaning and are not accustomed to investigate their hidden significance; but Mr. Bowie went so thoroughly into the analysis of their forms, strokes and pictorial values that his knowledge of the same often astounded and silenced my own countrymen. In addition to this, having undertaken to study Japanese painting, he placed himself under one of our most celebrated artists and, daily working with unabated zeal, in a comparatively short time made marvelous progress in that art. At one of our public art expositions he exhibited a painting of pigeons flying across a bamboo grove which was greatly admired and praised by everyone, but no one could believe that this was the work of a foreigner. At the conclusion of the exposition he was awarded a diploma attesting his merit. Many were the persons who coveted the painting, but as it had been originally offered to me, I still possess it. From time to time I refresh my eyes with the work and with much pleasure exhibit it to my friends. Frequently after this Mr. Bowie, always engaged in painting remarkable pictures in the Japanese manner, would exhibit them at the various art exhibitions of Japan, and was on two occasions specially honored by our Emperor and Empress, both of whom expressed the wish to possess his work, and Mr. Bowie had the honor of offering the same to our Imperial Majesties.

His reputation soon spread far and wide and requests for his paintings came in such numerous quantities that to comply his time was occupied continuously.

Now he is about to publish a work on Japanese painting to enlighten and instruct the people of Western nations upon our art. As I believe such a book must have great influence in promoting sentiments of kindliness between Japan and America, by causing the

Introduction

feelings of our people and the conditions of our national life to be widely known, I venture to offer a few words concerning the circumstances under which I first became acquainted with the author.

HIRAI KINZA,
NIHON AZUMA NO MIYAKO,
MEIJI-YOSA AMARI YOTOSE-HAZUKE.

Translated from the original manuscript of Hirai Kinza, noted scholar, lecturer and author.

Preface

THIS volume contains the substance of lectures on the laws and canons of Japanese painting delivered before the Japan Society of America, the Sketch Club of San Francisco, the Art Students of Stanford University, the Saturday Afternoon Club of Santa Cruz, the Arts and Crafts Guild of San Francisco, and the Art Institute of the University of California.

The interest the subject awakened encourages the belief that a wider acquaintance with essential principles underlying the art of painting in Japan will result in a sound appreciation of the artist work of that country.

Japanese art terms and other words deemed important have been purposely retained and translated for the benefit of students who may desire to seriously pursue Japanese painting under native masters. Those terms printed in small capitals are Chinese in origin; all others in italics are Japanese.

All of the drawings illustrative of the text have been specially prepared by Mr. Shimada Sekko, an artist of research and ability, who, under David Starr Jordan, has long been engaged on scientific illustrations in connection with the Smithsonian Institution.

The author apologizes for all references herein to personal experiences, which he certainly would have omitted could he regard the following pages as anything more than an informal introduction of the reader to the study of Japanese painting.

CONTENTS

[xi]

Contents

ILLUSTRATIONS

EXPLANATORY PLATES

[xiii]

EXPLANATORY PLATES

[xiv]

EXPLANATORY PLATES

[xv]

KEN WAN CHOKU HITSU

A firm arm and a perpendicular brush

ON THE LAWS OF JAPANESE PAINTING

PERSONAL EXPERIENCES

IN the year 1893 I went on a short visit to Japan, and becoming interested in much I saw there, the following year I made a second journey to that country. Taking up my residence in Kyoto, I determined to study and master, if possible, the Japanese language, in order to thoroughly understand the people, their institutions, and civilization. My studies began at daybreak and lasted till midday. The afternoons being unoccupied, it occurred to me that I might, with profit, look into the subject of Japanese painting. The city of Kyoto has always been the hotbed of Japanese art. At that time the great artist, Ko No Bairei, was still living there, and one of his distinguished pupils, Torei Nishigawa, was highly recommended to me as an art instructor. Bairei had declared Torei's ability was so great that at the age of eighteen he had learned all he could teach him. Torei was now over thirty years of age and a perfect type of his kind, overflowing with skill, learning, and humor. He gave me my first lesson and I was simply entranced.

Nine Years Under Japanese Masters

[3]

It was as though the skies had opened to disclose a
new kingdom of art. Taking his brush in hand,
with a few strokes he had executed a masterpiece,
a loquot (*biwa*) branch, with leaves clustering
round the ripe fruit. Instinct with life and beauty,
it seemed to have actually grown before my eyes.
From that moment dated my enthusiasm for Jap-
anese painting. I remained under Nishigawa for
two years or more, working assiduously on my
knees daily from noon till nightfall, painting on
silk or paper spread out flat before me, according to
the Japanese method.

Japanese painters are generally classed according
to what they confine themselves to producing.
Some are known as painters of figures (JIM BUTSU)
or animals (DO BUTSU), others as painters of land-
scapes (SAN SUI), others still as painters of flowers
and birds (KA CHO), others as painters of religious
subjects (BUTSU GWA), and so on. Torei was a
painter of flowers and birds, and these executed by
him are really as beautiful as their prototypes in
nature. On plate VII is given a specimen of his
work. He is now a leading artist of Osaka, where
he has done much to revive painting in that com-
mercial city.

As I desired to get some knowledge of Japanese
landscape painting, I was fortunate in next obtain-
ing instruction from the distinguished Kubota
Beisen, one of the most popular and gifted artists
in the empire.

In company with several of his friends and former
pupils I called upon him. After the usual words of

[4]

ceremony he was asked if he would kindly paint something for our delight. Without hesitation he spread a large sheet of Chinese paper (TOSHI) before him and in a few moments we beheld a crow clinging to the branches of a persimmon tree and trying to peck at the fruit, which was just a trifle out of reach. The work seemed that of a magician. I begged him then and there to give me instruction. He consented, and thus began an acquaintance and friendship which lasted until his death a few years ago. I worked faithfully under his guidance during five years, every day of the week, including Sundays. I never tired; in fact, I never wanted to stop. Every stroke of his brush seemed to have magic in it. (Plate IV.) In many ways he was one of the cleverest artists Japan has ever produced. He was an author as well as a painter, and wrote much on art. At the summit of his renown he was stricken hopelessly blind and died of chagrin,—he could paint no more.

While living in Tokio for a number of years I painted constantly under two other artists—Shimada Sekko, now distinguished for fishes; and Shimada Bokusen, a pupil of Gaho, and noted for landscape in the Kano style; so that, after nine years in all of devotion and labor given to Japanese painting, I was able to get a fairly good understanding of its theory and practice.

It may seem strange that one not an Oriental should become thus interested in Japanese painting and devote so much time and hard work to it; but the fact is, if one seriously investigates that art

Nine Years Under Japanese Masters

[5]

he readily comes under the sway of its fascination. Nine Years Under Japanese Masters As the people of Japan love art in all its manifestations, the foreigner who paints in their manner finds a double welcome among them; thus, ideal conditions are supplied under which the study there of art can be pursued.

My memory records nothing but kindness in that particular. During my long residence in Kyoto there were constantly sent to me for my enjoyment and instruction precious paintings by the old masters, to be replaced after a short time by other works of the various schools. For such attention I was largely indebted to the late Mr. Kumagai, one of Kyoto's most highly esteemed citizens and art patrons. Without multiplying instances of the generous nature of the Japanese and their interest in the endeavors of a foreigner to study their art, I will mention the gift from the Abbot of Ikegami of two original dragon paintings, executed for that temple by Kano Tanyu. In Tokio my dwelling was the frequent rendezvous of many of the leading artists of that city and GASSAKU painting was invariably our principal pastime. The great poet, Fukuha Bisei, now gone, would frequently join us, and to every painting executed he would add the embellishment of his charming inspirations in verse, written thereon in his inimitable *kana* script. This nobleman had taught the art of poetry to H. I. M. Mutsu Hito, to the preceding Emperor, and to the present Crown Prince.

[6]

CHAPTER TWO

ART IN JAPAN

I_N approaching a brief exposition of the laws of Japanese painting it is not my purpose to claim for that art superiority over every other kind of painting; nor will I admit that it is inferior to other schools of painting. Rather would I say that it is a waste of time to institute comparisons. Let it be remembered only that no Japanese painting can be properly understood, much less appreciated, unless we possess some acquaintance with the laws which control its production. Without such knowledge, criticism—praising or condemning a Japanese work of art—is without weight or value.

Japanese painters smile wearily when informed that foreigners consider their work to be flat, and at best merely decorative; that their pictures have no middle distance or perspective, and contain no shadows; in fact, that the art of painting in Japan is still in its infancy. In answer to all this suffice it to say that whatever a Japanese painting fails to contain has been purposely omitted. With Japanese artists it is a question of judgment and taste

[7]

as to what shall be painted and what best left out.

They never aim at photographic accuracy or distracting detail. They paint what they feel rather than what they see, but they first see very distinctly. It is the artistic impression (SHA I) which they strive to perpetuate in their work. So far as perspective is concerned, in the great treatise of Chu Kaishu entitled,"The Poppy-Garden Art Conversations," a work laying down the fundamental laws of landscape painting, artists are specially warned against disregarding the principle of perspective called EN KIN, meaning what is far and what is near. The frontispiece to the present volume illustrates how cleverly perspective is produced in Japanese art (Plate I).

Japanese artists are ardent lovers of nature; they closely observe her changing moods, and evolve every law of their art from such incessant, patient, and careful study.

These laws (in all there are seventy-two of them recognized as important) are a sealed book to the uninitiated. I once requested a learned Japanese to translate and explain some art terms in a work on Japanese painting. He frankly declared he could not do it, as he had never studied painting.

The Japanese are unconsciously an art-loving people. Their very education and surroundings tend to make them so, When the Japanese child of tender age first takes his little bowl of rice, a pair of tiny chop-sticks is put into his right hand. He grasps them as we would a dirk. His mother then shows him how he should manipulate them.

He has taken a first lesson in the use of the brush. With practice he becomes skilful, and one of his earliest pastimes is using the chop-sticks to pick up single grains of rice and other minute objects, which is no easy thing to do. It requires great dexterity. He is insensibly learning how to handle the double brush (NI HON *fude*), with which an artist will, among other things, lay on color with one brush and dilute or shade off (*kumadori*) the color with another, both brushes being held at the same time in the same hand, but with different fingers. Art Education in Japan

At the age of six the child is sent to school and taught to write with a brush the phonetic signs (forty-seven in number) which constitute the Japanese syllabary. These signs represent the forty-seven pure sounds of the Japanese language and are used for writing. They are known as *katakana* and are simplified Chinese characters, consisting of two or three strokes each. With them any word in Japanese can be written. It takes a year for a child to learn all these signs and to write them from memory, but they are an excellent training for both the eye and the hand. Japanese Written Characters

His next step in education is to learn to write these same sounds in a different script, called *hiragana*. These characters are cursive or rounded in form, while the *katakana* are more or less square. The *hiragana* are more graceful and can be written more rapidly, but they are more complicated.

From daily practice considerable training in the use of the brush and the free movement of the right arm and wrist is secured, and the eye is taught in-

sensibly the many differences between the square and the cursive form. Before the child is eight years old he has become quite skilful in writing with the brush both kinds of *kana*.

He is next taught the easier Chinese characters,— Chinese KANJI and ideographs. These are most ingeniously Written constructed and are of great importance in the fur-Characters ther training of the eye and hand.

So greatly do these wonderfully conceived written forms appeal to the artistic sense that a taste for them thus early acquired leads many a Japanese scholar to devote his entire life to their study and cultivation. Such writers become professionals and are called SHOKA. Probably the most renowned in all China was Ogishi. Japan has produced many such famous men, but none greater than Iwaya Ichi Roku, who has left an immortal name.

From what has been said about writing with the brush, it will be understood how the youth who may determine to follow art as a career is already well prepared for rapid strides therein. His hand and arm have acquired great freedom of movement. His eye has been trained to observe the varying lines and intricacies of the strokes and characters, and his sentiments of balance, of proportion, of accent and of stroke order, have been insensibly developed according to subtle principles, all aiming at artistic results.

The knowledge of Chinese characters and the Their ability to write them properly are considered of Importance in prime importance in Japanese art. A first counsel given me by Kubota Beisen was to commence that

[10]

ſtudy, and he personally introduced me to Ichiroku who, from that time, kindly supervised my many years of work in Chinese writing, a pursuit truly engrossing and captivating.

In all Japanese schools the rudiments of art are taught, and children are trained to perceive, feel, and enjoy what is beautiful in nature. There is no city, village, or hamlet in all Japan that does not contain its plantations of plum and cherry blossoms in spring, its peonies and lotus ponds in summer, its chrysanthemums in autumn, and camelias, mountain roses and red berries in winter. The school children are taken time and again to see these, and revel amongſt them. It is a part of their education. Excursions, called UNDOKAI, are organized at ſtated intervals during the school term and the scholars gaily tramp to diſtant parts of the country, singing patriotic and other songs the while and enjoying the view of waterfalls, broad and winding rivers, autumn maples, or snow-capped mountains. In addition to this, trips are taken to all famous temples and hiſtorical places including, where conveniently near, the three great views of Japan,—Matsushima, Ama No Hashi Date, and Myajima. Thus a taste for landscape is inculcated and becomes second nature. Furthermore, the scholars are encouraged to closely watch every form of life, including butterflies, crickets, beetles, birds, goldfish, shell-fish, and the like; and I have seen miniature landscape gardens made by Japanese children, moſt cleverly reproducing charming views

[11]

and contained in a shallow box or tray. This gentle little art is called BONSAI or *hako niwa*.

My purpose in alluding to all this is to indicate that a boy on leaving school has absorbed already much artistic education and is fairly well equipped for beginning a special course in the art schools of the empire.

Art Schools and Their Course

These schools differ in their methods of instruction, and many changes have been introduced in them during the present reign, or Meiji period, but substantially the course takes from three to four years and embraces copying (ISHA, *mitori*), tracing (MOSHA, *tsuki-utsushi*), reducing (SHUKUZU, *chijime-ru*), and composing (SHIKO, *tsukuri kata*).

In copying, the teacher usually first paints the particular subject and the student reproduces it under his supervision. Kubota's invariable method was to require the pupil on the following day to reproduce from memory (AN KI) the subject thus copied. This engenders confidence.

In tracing, thin paper is placed over the picture and the outlines (RIN KAKU) are traced according to the *exact order* in which the original subject was executed, an order which is established by rule; thus a proper style and brush habit are acquired. The correct sequence of the lines and parts of a painting is of the highest importance to its artistic effect.

In reducing the size of what is studied, the laws of proportion are insensibly learned. This is of great use afterwards in sketching (SHASSEI). I believe that in the habit of reproducing, as taught in

[12]

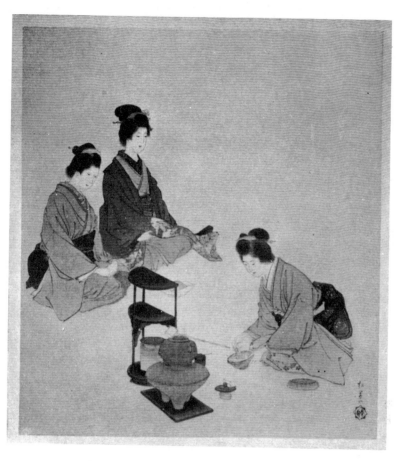

THE TEA CEREMONY
BY MISS UYEMURA SHOEN
Plate II

the schools, lies the secret of the extraordinary skill of the Japanese artisan who can produce marvelous effects in compressing scenery and other subjects within the very smallest dimensions and yet preserve correct proportions and balance. Nothing can excel in masterly reduction the miniature landscape work of the renowned Kaneiye, as exhibited in his priceless sword guards (*tsuba*).

Art Schools and Their Course

Sketching comes later in the course and is taught only after facility has been acquired in the other three departments. It embraces everything within doors and without—everything in the universe which has form or shape goes into the artist's sketch-book (KEN KON *no uchi* KEI SHO *arumono mina* FUN PON *to nasu*)—and forms part of the course in composition, which is intended to develop the imaginative faculties (SOZO). Kubota was so skilful in sketching that while traveling rapidly through a country he could faithfully reproduce the salient features of an extended landscape, conformable to the general rule in sketching, that what first attracts the eye is to be painted first, all else becoming subordinate to it in the scheme. Again, he could paint the scenery and personages of any historical song (*joruri*) as it was being sung to him, reproducing everything therein described and finishing his work in exact time with the last bar of the music. His arm and wrist were so free and flexible that his brush skipped about with the velocity of a dragon-fly. As an offhand painter (SEKIJO), or as a contributor to an impromptu picture in which several artists will in turn participate,

SEKIJO on Offhand Painting

[13]

GASSAKU such joint composition being known as GASSAKU, Kubota stood *facile princeps* among modern Japanese artists. The Kyoto painters have always been most gifted in that kind of accomplishment. In their day Watanabe Nangaku, a pupil of Okyo, Bairei, and Hyakunen, all of Kyoto, were famous as SEKIJO painters.

Relation of Master and Pupil

The art student having completed his course is now qualified to attach himself to some of the great artists, into whose household he will be admitted and whose *deshi* or art disciple he becomes from that time on. The relation between such master (SENSEI) and his pupil (*deshi*) is the most kindly imaginable. Indeed, *deshi* is a very beautiful word, meaning a younger brother, and was first applied to the Buddhist disciples of Shakka. The master treats him as one of his family and the pupil reveres the master as his divinity. Greater mutual regard and affection exist nowhere and many pupils remain more or less attached to the master's household until his death. To the most faithful and skilful of these the master bestows or bequeaths his name or a part of it, or his nom de plume (GO); and thus it is that the celebrated schools (RYUGI or HA or FU) of Japanese painting have been formed and perpetuated, beginning with Kanaoka, Tosa, Kano, and Okyo, and brought down to posterity through the devoted, and I might say sacred efforts of their pupils, to preserve the methods and traditions of those great men. Pupils of the earlier painters took their masters' family names, which accounts for so many Tosas and Kanos.

[14]

Great painters have always been held in high esteem in Japan, not only by their pupils, but also by the whole nation. Chikudo, the distinguished tiger painter, Bairei, one of the most renowned of the SHIJO HA or Maruyama school, Hashimoto Gaho, a pupil of Kano Massano and a leading exponent of the Kano style (Kano HA), and Katei, a Nangwa artist, all only recently deceased, were glorified in their lifetime. Strange to say, no one ever saw Gaho with brush in hand. He never would paint before his pupils or in any one's presence. His instructions were oral. On the other hand, Kubota Beisen was always at his best when painting before crowds of admirers. *Relation of Master and Pupil*

Prior to the Meiji period the great painters attached to the household of a Daimyo were called *O Eshi*. Painters who sold their paintings were styled *E kaki*. Now all painters are called GWA KA. Engravers, sculptors, print makers and the like were and still are denominated SHOKUNIN, meaning artisans. The comprehensive term "fine arts" (BIJUTSU) is of quite recent creation in Japan.

To say a few words about the different schools of painting in Japan, there were great artists there many centuries before Italy had produced Michael Angelo or Raphael. The art of painting began in Japan more than fifteen hundred years ago and has continued in uninterrupted descent from that remote time down to this forty-fourth year of Meiji, the present emperor's reign. No other country in the civilized world can produce such an art record. One thousand years before America was discovered, *The Historical Schools and Their Great Masters*

[15]

five hundred years before England had a name, and long before civilization had any meaning in Europe, there were artists in Japan following the profession of painting with the same ardor and the same intelligence they are now bestowing upon their art in this twentieth century of our era.

The Buddhist School

When Buddhism was introduced there in the sixth century, a great school of Buddhist artists began its long career. Among the names that stand out from behind the mist of ages is that of Kudara no Kawanari, who came from Corea.

Yamato School

In the ninth century lived the celebrated Kose Kanaoka. He painted in what was called the pure Japanese style, *yamato e*, *yamato* being the earliest name by which Japan was designated. He painted portraits and landscapes, and his school having a great following, lasted through five centuries. Kose Kimi Mochi, his pupil, Kimitada and Hirotaka were distinguished disciples of Kanaoka.

Tosa School

The Tosa school came next, beginning with Tosa Motomitsu, followed by Mitsunaga, Nobuzane and Mitsunobu. It dates back to the period of the Kamakura Shogunate eight hundred years ago. Its artists confined themselves principally to painting court scenes, court nobles, and the various ceremonies of court life. This school always used color in its paintings.

Sesshu

After Tosa came the schools of Sumiyoshi, Takuma, Kassuga, and Sesshu. Sesshu was a genius of towering proportions and an indefatigable artist of the very highest rank as a landscape painter. He had a famous pupil named Sesson.

[16]

Following Sesshu came the celebrated school of Kano artists, founded in the sixteenth century by Kano Masanobu. It took Japan captive. It had a tremendous vogue and following, and has come down to the present day through a succession of great painters. There were two branches, one in Edo (Tokyo), which included Kano Masanobu, Motonobu, his son, Eitoku, Motonobu's pupil, and later, Tanyu (Morinobu) Tanshin, his pupil, Koetsu, Naonobu, Tsunenobu, Morikage, Itcho, and finally Hashimoto Gaho, its latest distinguished representative, who is but recently deceased. The other branch, known as the Kyoto Kano, included the famous San Raku, Eino, San Setsu, and others. By some critics San Raku is placed at the head of all the Kano artists.

The Kano painters are remarkable for the boldness and living strength of the brush strokes (*fude no chicara* or *fude no ikioi*), as well as for the brilliancy or sheen (*tsuya*) and shading of the *sumi*. This latter effect—the play of light and shade in the stroke, considered almost a divine gift—is called BOKUSHOKU, and recalls somewhat the term *chiaroscuru*. The range of subjects of the Kano painters was originally limited to classic Chinese scenery, treated with simplicity and refinement, and to Chinese personages, sages and philosophers; color was used sparingly.

Other schools, more or less offshoots of the Kano style (RYU) of painting, came next—e. g., Korin and his imitator, Hoitsu, the DAIMYO of Sakai, who was said to use powdered gold and precious stones in

[17]

his pigments. Korin has never had his equal as a painter on lacquer. His work is said to be *le regal des delicats.*

Okyo School Another disciple of the Kano school, and a pupil of Yutei, was Maruyama Okyo, who founded in turn a school of art which is the most widely spread and flourishing in Japan today. Maruyama, not Okyo, was the family name of that artist. The name Okyo originated thus: Maruyama, much admiring an ancient painter named Shun Kyo, took the latter half of that name, Kyo, and prefixing an "O" to it, made it Okyo, which he then adopted. His style is called SHI JO FU, SHI JO being the name of that part of Kyoto where he resided, and FU meaning style or manner, and its characteristic is artistic fidelity to the objects represented. By some it is called the realistic school, and includes such well-known household names as Goshun, pupil of Busson, Sosen, the great monkey painter, Tessan (Plate III) and his son, Morikwansai, Bairei, Chikudo, the tiger painter, Hyakunen and his three pupils, Keinen, Shonen and Beisen, Kawabata Gyokusho, Torei, Shoen, and Takeuchi Seiho.

Nangwa, or Southern Chinese School There are still other schools (RYUGI) which might be mentioned, including that of the NANGWA, or southern painters, of Chinese origin and remarkable for the gracefulness of the brush stroke, the effective treatment of the masses and for the play of light and shade throughout the composition. Among the great NANGWA painters are Taigado, Chikuden, Baietsu (Plate VIII) and Katei. To this school is referred a style of painting affected ex-

[18]

clusively by the professional writers of Chinese
characters, and called BUNJINGWA. To these I will
allude further on. The versatile artist, Tani Buncho, Tani Buncho
created a school which had many adherents, in-
cluding the distinguished Watanabe Kwazan and
Eiko of Tokyo, lately deceased, one of its best
exponents.

The art of painting is enthusiastically pursued
at the present time in Kyoto, Tokyo, Nagoya and
Osaka. In Tokyo, Hashi Moto Gaho was generally Hashi Moto Gaho
conceded to be, up to the time of his death in 1908,
the foremost artist in Japan. Although of the
Kano school, he greatly admired European art, and
the treatment of the human figure in some of his
latest paintings recalls the manner of the early
Flemish artists.

My first meeting with Gaho was at his home.
While waiting for him, I observed suspended in
the *tokonoma,* or alcove, a narrow little *kakemono*
by Kano Moto Nobu, representing an old man upon
a donkey crossing a bridge. A small bronze vase
containing a single flower spray was the sole or-
nament in the room. This gave the keynote to
Gaho's character—classic simplicity, ever reflected
in his work. He had many followers. His method
of instruction with advanced pupils was to give
them subjects such as "A Day in Spring," "Soli-
tude," "An Autumn Morning," or the like, and he
was most insistent upon all the essentials to the
proper effect being introduced. His criticisms were
always luminous and sympathetic. He advised his
students to copy everything good, but to imitate no

[19]

one,—to develop individuality. He left three very
His best pupils distinguished and able pupils—Gyokudo, Kan Zan
and Boku Sen.

Kawabata
Gyokusho Since Gaho's death, Kawabata Gyokusho, an
Okyo artist, is the recognized leader of the capital.
Takeuchi
Seiho In Kyoto, Takeuchi Seiho, an early pupil of Bairei,
now occupies the foremost place, although Shonen
and Keinen, pupils of Hyakunen, still hold a high
rank.

Recurring to the time of Tosa, there is another
The *Ukiyo e*
School—Prints school beginning under Matahei and perpetuated
through many generations of popular artists, in-
cluding Utamaro, Yeisen and Hokusai, and coming
down to the present date. This is the *Ukiyo e* or
floating-world-picture school. It is far better known
through its prints than its paintings. The great
painters of Japan have never held this school in any
favor. At one time or another I have visited nearly
every distinguished artist's studio in Japan, and I
know personally most of the leading artists of that
country. I have never seen a Japanese print in the
possession of any of them, and I know their senti-
ments about all such work. A print is a lifeless
production, and it would be quite impossible for a
Japanese artist to take prints into any serious con-
sideration. They rank no higher than cut velvet
scenery or embroidered screens. I am aware that
such prints are in great favor with many enthu-
siasts and that collectors highly value them; but
they do not exemplify art as the Japanese under-
stand that term. It must be admitted, however,
that the prints have been of service in several

[20]

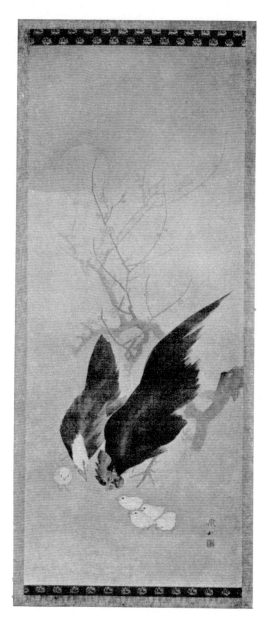

CHICKENS IN SPRING
BY MORI TESSAN
Plate III

ways. They first attracted the world's attention to the subject of Japanese art in general. Commencing with an exhibition of them in London a half century ago, the prints of Ukiyo or genre subjects came rapidly into favor and ever since have commanded the notice and admiration of collectors in Europe and America. Many people are even under the impression that the prints represent Japanese painting, which, of course, is a great mistake. There have been artists in Japan who, in the *Ukiyo e* manner, have painted *kakemono,* BYOBU and *makimono.* The word *kakemono* is applied to a painting on silk or paper, wound upon a wooden roller and unrolled and hung up to be seen. *Kakeru* means to suspend and *mono* means an object, hence *kakemono,* a suspended object. BYOBU signifies wind protector or screen; *makimono,* meaning a wound thing, is a painting in scroll form. It is not suspended, but simply unrolled for inspection. Such original work by Matahei and others is extant. But most of the *Ukiyo e,* or pictures in the popular style, are prints struck from wood blocks and are the joint production of the artist, the wood engraver, the color smearer and the printer, all of whom have contributed to and are more or less entitled to credit for the result; and that is one reason why the artist-world of Japan objects to or ignores them; they are not the spontaneous, living, palpitating production of the artist's brush. It is well known that artists of the *Ukiyo e* school frequently indicated only by written instructions how their outline drawings for the prints should be colored,

The *Ukiyo e* School—Prints

[21]

leaving the detail of such work to the color smearer.
Apart from the fact that the colors employed
were the cheapest the market afforded, and are
found often to be awkwardly applied, there is too
much about the prints that is measured, mechanical
and calculated to satisfy Japanese art in its high-
est sense. Frequently more than one engraver was
employed upon a single print. The engravers had
their specialties; some were engaged for the coif-
fure or head-dress (*mage*), other for the lines of the
face, others for the dress (*kimono*), others still for
pattern (MOYO), et cetera. The most skilful engravers
in Yedo were called *kashira bori* and were always
employed on Utamaro and Hokusai prints. Many
of the colors of these prints in their soft, neutral
shades, are rapturously extolled by foreign connois-
seurs as evidence of the marvelous taste of the
Japanese painter. But, really, time more than art
is to be credited with toning down such tints to
their present delicate hues. In this respect, like
Persian rugs, they improve with age and exposure.

An additional objection to most of the prints is
that they reproduce trivial, ordinary, every-day
occurrences in the life of the mass of the people as
it moves on. They are more or less plebian. The
prints being intended for sale to the common
people, the subjects of them, however skilfully
handled, had to be commonplace. They were not
purchased by the nobility or higher classes. Sol-
diers, farmers, and others bought them as presents
(*miage*) for their wives and children, and they were
generally sold for a penny apiece, so that in Japan

[22]

prints were a cheap substitute for art with the lower classes, just as Raspail says garlic has always been the camphor of the poor in France. The practice of issuing *Ukiyo e* prints at very low prices still continues in Tokyo, where every week or two such colored publications are strung up in front of the book-stalls and are still as eagerly purchased by the common people as they were in Tokugawa days.

The prices the old prints now bring are out of all proportion to their intrinsic value, yet, such is the crescendo craze to acquire them that Japan has been almost drained of the supply, the number of prints of the best kind being limited, like that of Cremona violins of the good makers.

Prints are genuine originals of a first or subsequent issue, called respectively, SHO HAN and SAI HAN, or they are reproductions more or less cleverly copied upon new blocks, or they are fraudulent imitations (GANBUTSU) of the original issues, often difficult to detect. The very wormholes are burnt into them with SENKO or perfume sticks and clever workmen are employed to make such and other trickery successful. A long chapter could be written about their dishonest devices. Copies of genuine prints (HON KOKU), made from new blocks after the manner of the ancient ones, abound, and were not intended to pass for originals. Yedo, where the print industry was chiefly carried on, has had so many destructive conflagrations that most of the old *Ukiyo e* blocks have been destroyed. At Nagoya the house of To Heki Do still preserves the original blocks of the MANGWA or miscellaneous drawings of

[23]

Hokusai, but they are much worn. Prints are known by various names, such as *ezoshi* (illustrations), *nishiki e, edo e* (Yedo pictures), *surimono* and INSATSU. It may be of interest to know that the print blocks, when so worn as to be no longer serviceable for prints, are sometimes converted into fire-boxes (*hibachi*) and tobacco trays (*tabacco bon*) which, when highly polished, are decorative and unique.

Perhaps a useful purpose prints have served is to record the manners and customs of the people of the periods when they were struck off. They show not only prevailing styles of dress and head-dress, but also the pursuits and amusements of the common folk. They are excellent depositaries of dress pattern (MOYO) or decoration, upon which fertile subject Japan has always been a leading authority. In the early Meiji period print painters frequently delegated such minute pattern work to their best pupils, whose seals (IN) will be found upon the prints thus elaborated. The prints preserve the ruling fashions of different periods in combs and other hair ornaments, fans, foot-gear, single and multiple screens, fire-boxes and other household ornaments and utensils. They also furnish specimens of temple and house architecture, garden plans, flower arrangements (*ike bana*), bamboo, twig and other fences. Again, they reproduce the stage, with its famous actors in historical dramas; battle scenes, with warriors and heroes; characters in folk-lore and other stories, and wrestling matches, with the popular champions; and we will often find upon

[24]

the face of the print good reproductions of Chinese and Japanese writing, in poems and descriptive prose pieces. Hokusai illustrated much of the classic poetry of China and Japan, as well as the SENJIMON, or Thousand Character Chinese classic, a work formerly universally taught in the Japanese schools. The original characters for this remarkable compilation were taken from the writings of Ogishi. The prints have aided in teaching elementary history to the young; the knowledge of Japanese children in this connection is often remarkable and may be attributed to the educational influence of the *Ukiyo e* publications.

The *Ukiyo e* School—Prints

So there are certainly good words to be said for the prints, but they are not Japanese art in its best sense, however interesting as a subordinate phase of it, and in no sense are they Japanese painting.

If limited to a choice of one artist of the *Ukiyo e* school, no mistake would be made, I think, in selecting Hiroshige, whose landscapes fairly reproduce the sentiment of Japanese scenery, although the prints bearing his name fall far short of reproducing that artist's color schemes. Hokusai's reputation with foreigners is greater than Hiroshige's, but Japanese artists do not take Hokusai seriously. His pictures, they declare, reflect the restlessness of his disposition; his peaks of Fuji are all too pointed, and his manner generally is exaggerated and theatrical. Utamaro's women of the Yoshiwara are certainly careful studies in graceful line drawing,—as correct as Greek drapery in marble.

[25]

Iwasa Matahei, the founder of the popular school, was a pupil of Mitsunori, a Kyoto artist and follower of Tosa. Matahei disliked Tosa subjects and preferred to depict the fleeting usages of the people, so he was nicknamed Fleeting World or *Ukiyo* Matahei, and thus originated the name *Ukiyo e* or pictures of every-day life. There are no genuine Matahei prints. He dates back to the seventeenth century. Profile faces in original screen paintings by him have an Assyrian cast of countenance, the eye being painted as though seen in full face.

Hishikawa Moronobu was his follower and admirer. He was an artist of Yedo. Nishikawa Sukenobu belonged to the Kano school and was a pupil of Kano Eiko. He adopted the *Ukiyo e* style and depicted the pastimes of women and the portraits of actors. He lived two hundred and twenty years ago and in his time prints came greatly into vogue. Torii Kyonobu painted women and actors and invented the kind of pictured theatrical posters which are still in fashion, placarded at the entrance to theaters and showing striking incidents in the play.

Suzuki Harunobu never painted actors, preferring to reproduce the feminine beauties of his time. It was to his careful work that was first applied the term *nishiki e* or brocade pictures, on account of the charm of his decorative manner. He lived one hundred and thirty years ago.

Among the many able foreign writers on Japanese prints Fenollosa stands prominent. He resided for a long time in Japan, understood and spoke the

language, and lived the life of the people. He was in great sympathy with them and with their art and enjoyed exceptional opportunities for seeing and studying the best treasures of that country. Had he possessed the training necessary to paint in the Japanese style I do not think he would have devoted so much time to Japanese woodcuts.

Visiting me at Kyoto, where I was busily engaged in painting, "Ah!" he cried, "that is what I have always longed to do. Sooner or later I shall follow your example." But he never did. Instead, he issued a large work on Japanese prints. His death was a real loss to the art literature of Japan. During eight years he was in the service of the Japanese government ransacking, cataloguing and photographing the multitudinous art treasures, paintings, *kakemono*, *makimono*, and BYOBU (pictures, scrolls and screens), to be found in the various Buddhist and other temples and monasteries scattered throughout the empire. The last time we met, he remarked, "How can one willingly leave this land of light? Japan, to my mind, stands for whatever is beautiful in nature and true in art; here I hope to pass the remaining years of my life." Such was his genuine enthusiasm, engendered by a long acquaintance with art and everything else beautiful in that country. Japan impresses in this way all who see it under proper conditions, but unfortunately the ordinary traveler, pushed for time, and whose acquaintance is limited to professional guides, never gets much beyond the sights, the shops and the curio dealers.

[27]

On the Laws of Japanese Painting

Books on
Japanese Art

The question is often asked, "Is there any good book on Japanese painting?" I know of none in any language except Japanese. The following are among the best works on the subject:

A History of Japanese Painting (Hon Cho Gashi), by Kano Eno.

A Treasure Volume (Bampo Zen Sho), by Ki Moto Ka Ho.

The Painter's Convenient Reference (Goko Ben Ran), by Arai Haku Seki.

A Collection of Celebrated Japanese Paintings (Ko Cho Meiga Shu e), by Hiyama Gi Shin.

Ideas on Design in Painting (To Ga Ko), by Saito Heko Maro.

A Discourse on Japanese Painting (Honcho Gwa San), by Tani Buncho.

Important Reflections on All Kinds of Painting (Gwa Jo Yo Ryaku), by Arai Kayo.

A Treatise on Famous Japanese Paintings (Fu So Mei Gwa Den), by Hori Nao Kaku.

Observations on Ancient Pictures (Ko Gwa Bi Ko), by Asa Oka Kotei.

A Treatise on Famous Painters (Fu So Gwa Jin), by Ko Shitsu Ryo Chu.

A Treatise on Japanese Painting (Yamato Nishiki Kem Bun Sho), by Kuro Kama Shun Son.

A Treatise on the Laws of Painting (Gwafu), by Ran Sai, a pupil of Chinanpin. The work is voluminous and is both of great use and authority.

Cho Chu Gwa Fu, by Chiku To.

Sha Zan Gakugwa Hen, by Buncho.

Translations of all these works into English are greatly to be desired.

There is much that has been sympathetically written and published about Japanese paintings both in Europe and America, but however laudatory, it might be all summed up under the title, "Impressions of an Outsider." Such writings lack

[28]

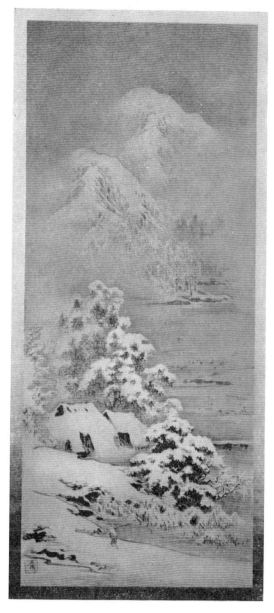

SNOW SCENE IN KAGA
BY KUBOTA BEISEN
Plate IV

the authority which only constant labor in the field of practical art can confer. A Japanese artist, by which I mean a painter, is long in making. From ten to fifteen years of continuous study and application are required before much skill is attained. During that time he gradually absorbs a knowledge of the many principles, precepts, maxims and methods, which together constitute the corpus or body of art doctrine handed down from a remote antiquity and preserved either in books or perpetuated by tradition. Along with these are innumerable art secrets called *hiji* or *himitsu*, never published, but orally imparted by the masters to their pupils—not secrets in a trick sense, but methods of execution discovered after laborious effort and treasured as valued possessions. It is obvious, then, how incapable of writing technically upon the subject must anyone be who has not gone through such curriculum and had drilled into him all that varied instruction which makes up the body of rules applicable to that art.

I have read many seriously written appreciations of Japanese paintings published in various modern languages, and even some amiable imaginings penned for foreigners by Japanese who fancy they know by instinct what only can be acquired after long study and practice with brush in hand. All such writers are characterized in Japan by a very polite term, *shiroto*—which means amateur. It also has a secondary signification of emptiness.

LAWS FOR THE USE
OF BRUSH AND MATERIALS

Introductory
Remarks

UPON a subject as technical as that of Japanese painting, to endeavor to impart correct information in a way that shall be both instructive and entertaining is an undertaking of no little difficulty. The rules and canons of any art when enumerated, classified and explained, are likely to prove trying, if not wearisome reading. Yet, if our object be to acquire accurate knowledge, we must consent to make some sacrifice to attain it, and there is no royal road to a knowledge of Japanese painting.

We have little or no opportunity in America, excepting in one or two cities, to see good specimens of the work of the great painters of Japan. Furthermore, such work in *kakemono* form is seen to much disadvantage when exhibited in numbers strung along the walls of a museum. Japanese *kakemono* (hanging paintings) are best viewed singly, suspended in the recess of the *tokonoma*, or alcove. A certain seclusion is essential to the enjoy-

[30]

ment of their delicate and subtle effects; the surroundings should be suggestive of leisure and repose, which the Japanese word *shidzuka*, often employed in art language, well describes.

The Japanese technique, by which I understand the established manner in which their effects in painting are produced, differs widely from that of European art. The Japanese brushes (*fude* and *hake*), colors and materials influence largely the method of painting. The canons or standards by which Japanese art is to be judged are quite special to Japan and are scarcely understood outside of it. Since the subject is technical, to treat it in a popular way is to risk the omission of much that is essential. I will endeavor, at any rate, to give an outline of its fundamental principles, first saying a word or two about the tools and materials.

In Japanese painting no oils are used. *Sumi* (a black color in cake form) and water-colors only are employed, while Chinese and Japanese paper and specially prepared silk take the place of canvas or other material.

Japanese artists do not paint on easels; while at work they sit on their heels and knees, with the paper or silk spread before them on a soft material, called *mosen*, which lies upon the matting or floor covering. After one becomes accustomed to this position, he finds it gives, among other things, a very free use of the right arm and wrist.

Silk (*e ginu*) is prepared for painting by first attaching it with boiled rice mucilage to a stretching frame. A sizing of alum and light glue (called

[31]

dosa) is next applied, care being taken not to wet the edges of the silk attached to the frame, which would loosen the silk.

It has been found that paper lasts much longer than silk, and also can be more easily restored when cracked with age.

The artists of the Tosa school used a paper called *tori no ko*, into the composition of which egg-shells entered. This paper was a special product of Ichi Zen.

The Kano artists used both *tori no ko* and a paper made from the mulberry plant, also a product of Ichi Zen, and known as *hosho*. For ordinary tracing a paper called TENGU JO is used. In Okyo's time, Chinese paper made from rice-plant leaves came into vogue. It is manufactured in large sheets and is called TOSHI. It is a light straw color, and is very responsive to the brush stroke, except when it "catches cold," as the Japanese say. It should be kept in a dry place.

The Tosa artists used paper almost to the exclusion of silk. The Kano school largely employed silk for their paintings. Okyo also usually painted on silk.

Japanese artists seldom outline their work. In painting on silk, a rough sketch in *sumi* is sometimes placed under the silk for guidance. Outlining on paper is done with straight willow twigs of charcoal, called *yaki sumi*, easily erased by brushing with a feather.

There are strict, and when once understood, reasonable and helpful laws for the use of the

[32]

brush (YOHITSU), the use of *sumi* (YOBOKU) and the use of water-colors (SESSHOKU). These laws reach from what seems merely the mechanics of painting into the highest ethics of Japanese art.

The law of YO HITSU requires a free and skilful handling of the brush, always with strict attention to the stroke, whether dot, line or mass is to be made; the brush must not touch the silk or paper before reflection has determined what the stroke or dot is to express. Neither negligence nor indifference is tolerated.

How the Brush is Used (YO HITSU)

An artist, be he ever so skilful, is cautioned not to feel entirely satisfied with his use of the brush, as it is never perfect and is always susceptible of improvement. The brush is the handmaid of the artist's soul and must be responsive to his inspiration. The student is warned to be as much on his guard against carelessness when handling the brush as if he were a swordsman standing ready to attack his enemy or to defend his own life; and this is the reason: Everything in art conspires to prevent success. The softness of the brush requires the stroke to be light and rapid and the touch delicate. The brush, when dipped first into the water, may absorb too much or not enough, and the *sumi* or ink taken on the brush may blot or refuse to spread or flow upon the material, or it may spread in the wrong direction. The Chinese paper (TOSHI) which is employed in ordinary art work may be so affected by the atmosphere as to refuse to respond, and the brush stroke must be regulated accordingly. All such matters have to

be considered when the brush is being used, and if
How the
Brush is Used
(YO HITSU) the spirit of the artist be not alert, the result is failure. (IT TEN ICHI BOKU *ni* CHIU *o su beki.*)

Vehicle of the subtle sentiment to be expressed in form, the brush must be so fashioned as to receive and transmit the vibrations of the artist's inner self. Much care, much thought and skill have been expended in the manufacture of the brush.

How the
Brush is Made
In China, the art of writing preceded painting, and the first brushes made were writing brushes, and the more writing developed into a wonderful art, the more attention was bestowed upon the materials composing the writing brush. Such brushes were originally made with rabbit hair, round which was wrapped the hair of deer and sheep, and the handles were mulberry stems. Later on, as Chinese characters became more complex and writing more scientific, the brushes were most carefully made of fox and rabbit hair, with handles of ivory, and they were kept in gold and jeweled boxes. Officials were enjoined to write all public documents with brushes having red lacquer handles, red being a positive or male (YO) color. Ogishi, the greatest of the Chinese writers, used for his brushes the feelers from around the rat's nose and hairs taken from the beak of the kingfisher.

In Japan, hair of the deer, badger, rabbit, sheep, squirrel, and wild horse all enter into the manufacture of the artist's brush, which is made to order, long or short, soft or strong, stiff or pliable. For laying on color, the hair of the badger is preferred. The sizes and shapes of brushes used differ

[34]

according to the subject to be painted. There are brushes for flowers and birds, human beings, landscapes, lines of the garments, lines of the face, for laying on color, for shading, et cetera.

A distinguishing feature in Japanese painting is the strength of the brush stroke, technically called *fude no chikara* or *fude no ikioi*. When representing an object suggesting strength, such, for instance, as a rocky cliff, the beak or talons of a bird, the tiger's claws, or the limbs and branches of a tree, the moment the brush is applied the sentiment of strength must be invoked and felt throughout the artist's system and imparted through his arm and hand to the brush, and so transmitted into the object painted; and this nervous current must be continuous and of equal intensity while the work proceeds. If the tree's limbs or branches in a painting by a Kano artist be examined, it will astonish any one to perceive the vital force that has been infused into them. Even the smallest twigs appear filled with the power of growth—all the result of *fude no chikara*. Indeed, when this principle is understood, and in the light of it the trees of many of the Italian and French artists are critically viewed, they appear flabby, lifeless, and as though they had been done with a feather. They lack that vigor which is attained only by *fude no chikara*, or brush strength.

In writing Chinese characters in the REI SHO manner this same principle is carefully inculcated. The characters must be executed with the feeling of their being carved on stone or engraved on

Strength of the Brush Stroke (*fude no chikara*)

[35]

steel—such must be the force transmitted through the arm and hand to the brush. Thus executed the writings seem imbued with living strength.

It is related of Chinanpin, the great Chinese painter, that an art student having applied to him for instruction, he painted an orchid plant and told the student to copy it. The student did so to his own satisfaction, but the master told him he was far away from what was most essential. Again and again, during several months, the orchid was reproduced, each time an improvement on the previous effort, but never meeting with the master's approval. Finally Chinanpin explained as follows: The long, blade-like leaves of the orchid may droop toward the earth but they all long to point to the sky, and this tendency is called cloud-longing (BO UN) in art. When, therefore, the tip of the long slender leaf is reached by the brush the artist must feel that the same is longing to point to the clouds. Thus painted, the true spirit and living force (*kokoromochi*) of the plant are preserved.

Kubota recommended to art students and artists a practice with lines which is excellent for acquiring and retaining firmness and freedom of the arm, with steady and continuous strength in the stroke. With a brush held strictly perpendicular to the paper horizontal lines are painted, first from right to left, the entire width of the TOSHI or other paper, each line with equal thickness and unwavering intensity of power throughout its entire length. The thickness of the line will depend upon the amount of hair in the brush that is allowed to

[36]

touch the paper; if only the tip of the brush be used, the line will be slender or thin; but, whether a broad band or a delicate tracing, it muſt be uni- form throughout and filled with living force. Next, the lines are painted from left to right in the same way and with the same close attention to uniform thickness and continuous flow of nervous ſtrength from ſtart to finish. Then, the increasingly diffi- cult task is to paint them from top to bottom of the TOSHI, and finally, moſt difficult and moſt important of all these exercises, the parallel lines are traced from bottom to top of the paper. The thinner the line the more difficult it is to execute, because of the tendency of the hand to tremble. Indeed, the difficulty is supreme. Let any one who is intereſted try this; it is an exercise for the moſt expert. Such lines resemble the *sons filés* on the violin, where a continuous suſtained tone of equal intensity is produced by drawing the bow from heel to tip so slowly over the ſtrings that it hardly moves. Praćticing lines in the way indicated gives ſteadiness and ſtrength, qualities in demand at every inſtant in Japanese art. Observe a Japanese artiſt paint the young branch of a plum tree shoot- ing from the trunk. The new year's growth ſtart- ing, it may be, from the bottom of the TOSHI will be projećted to the top. Examine it carefully and it will be found to conform to that principle of *fude no chikara* which transfers a living force into the branch. I have seen European artiſts in Japan vainly try offhand to produce such effećts; but these depend on long and patient praćtice.

[37]

ON THE LAWS OF JAPANESE PAINTING

A Japanese artist will frequently ignore the boundaries of the paper upon which he paints by beginning his stroke upon the MOSEN and continuing it upon the paper—or beginning it upon the paper and projecting it upon the MOSEN. This produces the sentiment or impression of great strength of stroke. It animates the work. And in this energetic kind of painting, if drops of *sumi* accidentally fall from the brush upon the painting they are regarded as giving additional energy to it. Similarly, if the stroke on the trunk or branch of a tree shows many thin hair lines where the intention was that the line should be solid, this also is regarded as an additional evidence of stroke energy and is always highly prized.

The same principle applies in the art of Chinese writing; but this effect must not be the result of calculation—it must be what in art is called SHI ZEN, meaning spontaneous.

In painting the hair of monkeys, bears and the like, the pointed brush is flattened and spread out (*wari fude*) so that each stroke of the same will reproduce numberless thin lines, corresponding to the hairs of the animal. Sosen thus painted. In modern times Kimpo (Plate v) is justly renowned for such work.

Many artists become wonderfully expert in the use of the flat brush, from one to four inches wide, called *hake*, by means of which instantaneous effects such as rain, rocks, mountain chains and snow scenes are secured. Some artists acquire a special reputation for skill in the use of the *hake*.

Use of Brush and Materials

The brush should be often and thoroughly rinsed during the time that it is used and washed and dried when not employed. In Kyoto, Osaka and Tokyo there are famous manufacturers of artists' brushes, and names of makers such as Nishimura, Sugiyama, Hakkado, Onkyodo and Kiukyodo are familiar to all the artists of the country.

The use of *sumi* (YOBOKU) is the really distinguishing feature of Japanese painting. Not only is this black color (*sumi*) used in all water color work, but it is frequently the only color employed; and a painting thus executed, according to the laws of Japanese art, is called *sumi e* and is regarded as the highest test of the artist's skill. Colors can cheat the eye (*damakasu*) but *sumi* never can; it proclaims the master and exposes the tyro.

The terms "study in black and white," "India ink drawing" and the like, since all are only makeshift translations, are misleading. The Chinese term "BOKUGWA" is the exact equivalent of *sumi e* and both mean and describe the same production. *Sumi e* is not an "ink picture," since no ink is used in its production. Ink is the very opposite of *sumi* both in its composition and effect. Ink is an acid and fluid. *Sumi* is a solid made from the soot obtained by burning certain plants (for the best results *juncus communis*, bull rush, or the *sessamen orientalis*), combined with glue from deer horn. This is molded into a black cake which, drying thoroughly if kept in ashes, improves with age. In much of the good *sumi* crimson (*beni*) is added for the sheen, and musk perfume (*jako*) is intro-

[39]

duced for antiseptic purposes. When a dead finish

or surface (*tsuya o keshi*) is desired, as, for instance, where the female coiffure is to be painted and a lusterless ground is needed for contrast with the shining strands of the hair, a little white pulverized oyster shell, called GO FUN, is mixed with the *sumi*. Commercial India ink resembles *sumi* in appearance, but is very inferior to it in quality. The methods of *sumi* manufacture are carefully guarded secrets. China during the Ming dynasty, three centuries ago, produced the best *sumi*, although China *sumi* (TOBOKU) employed twelve centuries past shows both in writing and in painting as distinctly and brilliantly today as though it were but recently manufactured. Nara, near Kyoto, was the birthplace of Japanese *sumi*, and the house of Kumagai (*Kyukyodo*) for centuries has had its manufacturers in that city. In Tokyo a distinguished maker, whose *sumi* many of the artists there prefer, is Baisen. He has devoted fifty years of his life to the study and compounding of this precious article. He possesses some great secrets of manufacture which may die with him. In Okyo's time there was a dark blue *sumi* called AI EN BOKU but the art and secret of its manufacture are lost.

In using *sumi* the cake is moistened and rubbed on a slab called *suzuri*, producing a semi-fluid. The well-cleaned brush is dipped first into clear water and then into the prepared *sumi*. When the *sumi* is taken on the brush it should be used without delay; otherwise it will mingle with the

[40]

water of the brush and destroy the desired balance
between the water and the *sumi*. For careful work
the *sumi* is first transferred on the brush from the
suzuri to a white saucer, where it is tested. It is a
singular fact that the color of *sumi* will differ
according to the manner in which it is rubbed
upon the stone. The best results are obtained
when a young maiden is employed for the purpose,
her strength being just suitable.

It is very important while painting with *sumi*
to renew its strength frequently by fresh applica-
tions of the cake to the slab. The color and rich-
ness of *sumi* left upon the slab soon fade; and
though when used this may not be apparent, when
the *sumi* dries on the paper or silk its weakness is
speedily perceived.

By the dexterous use of *sumi* colors may be suc-
cessfully suggested, materials apparently repro-
duced and by what is termed BOKUSHOKU, or the
brush-stroke play of light and shade, the very rays
of the sun may be imprisoned within the four cor-
ners of a picture. Artists are readily recognized in
their work by their manner of using or laying on
sumi. The color, the sheen, the shadings and the
flow of the ink enable us even to determine the
disposition or state of mind of the artist at the
time of painting, so sensitive, so responsive is *sumi*
to the mood of the artist using it. There is much
of engaging interest in connection with this sub-
ject. Artists become most difficult to satisfy on
the subject of the various kinds of *sumi*, which dif-
fer as much in their special qualities as the tones

of celebrated violins. It is interesting to observe

how different the color or richness of the same *sumi* becomes according to the varying skill with which it is applied.

The mineral character of the *suzuri* has also

much to do with the production of the best and richest black tones.

The most valuable stone for *suzuri* is known throughout the entire oriental world as TAN KEI and is found in the mountain of Fuka in China. This stone has gold streaks through it, with small dots called bird's eyes. The water which flows from Fuka mountain is blue. The color of the rock is violet. A favorite color for the *suzuri* (in Chinese called KEN) is lion's liver. Formerly much ceremony was observed in mining for this stone and sheep and cattle were offered in sacrifice, else it was believed that the stone would be struck by a thunderbolt and reduced to ashes in the hands of its possessor. The *suzuri* is also made in China from river sediment fashioned and baked. Still another method is to make the *suzuri* from paper and the varnish of the lacquer tree. Such are called paper *suzuri* (SHI KEN). In Thibet *suzuri* are made from the bamboo root. In Japan the best stones for *suzuri* are found near Hiroshima in Kiushu, the grain being hard and fine.

The skilful use of water colors is called SESSHOKU. It is more difficult to paint with *sumi* alone than

to paint with the aid of colors, which can hide defects never to be concealed in a *sumi e*, where painting over *sumi* a second time is disastrous.

[42]

Use of Brush and Materials

Japanese painters as a rule are sparing of colors, the slightest amount used discreetly and with restraint generally sufficing. Many artists have not the color sense or dislike color and seldom use it. Kubota often declared he hoped to live until he might feel justified in discarding color and employing *sumi* alone for any and all effects in painting. Use of Water Colors (SESSHOKU)

There are eight different ways of painting in color. I will enumerate them, with their technical, descriptive terms: The Eight Ways of Painting in Color

In the best form of color painting (GOKU ZAI SHIKI) (Plate IX) the color is most carefully laid on, being applied three times or oftener if necessary. On account of these repeated coats this form is called TAI CHAKU SHOKU. This style of painting is reserved for temples, gold screens, palace ceilings and the like. Tosa and *Yamato e* painters generally followed this manner.

The next best method of coloring (CHU ZAI SHIKI) (Plate X) is termed CHAKU SHOKU, or the ordinary application of color. The Kano and Shijo schools use this method extensively, as did also the *Ukiyo e* painters.

The light water-color method, called TAN SAI (Plate XI), is employed in the ordinary style of painting *kakemono* and is much used by the Okyo school.

The most interesting form of painting, technically called BOKKOTSU (Plate XII), is that in which all outlines are suppressed and *sumi* or color is used for the masses. Another Japanese term for the same is *tsuketate*.

[43]

The Eight
Ways of
Painting in
Color
The method of shading, called GOSO (Plate XIII), invented by a Chinese artist, Godoshi, who lived one thousand years ago, consists in applying dark brown color or light *sumi* wash over the *sumi* lines. This style was much employed by Kano painters and for art printing.

The light reddish-brown color, technically called SENPO SHOKU (Plate XIV), is mostly used in printing pictures in book form.

Another form similarly used is called HAKUBYO (Plate xv) or white pattern, no color being employed.

Lastly, there is the *sumi* picture or *sumi e* (Plate XVI), technically called SUIBOKU,—to which reference has already been made—where *sumi* only is employed, black being regarded as a color by Japanese artists.

Autumn Tints
A well-known method by which the autumnal tints of forest leaves are produced is to take up with the brush one after another and in the following order these colors: Yellow-green (*ki iro*), brown (TAI SHA), red (SHU), crimson (*beni*), and last, and on the very tip of the brush, *sumi*. The brush thus charged and dexterously applied gives a charming autumn effect, the colors shading into each other as in nature.

Parent Colors
and Their
Combinations
There are five parent colors in Japanese art: Blue (SEI), yellow (AU), black (KOKU), white (BYAKU), and red (SEKI). These in combination (CHO GO) originate other colors as follows: Blue and yellow produce green (*midori*); blue and black, dark blue (*ai nezumi*); blue and white, sky-blue (*sora iro*);

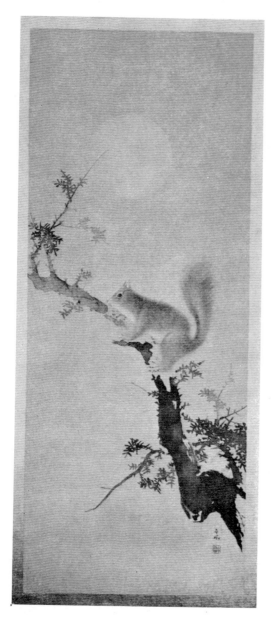

TREE SQUIRREL
BY MOCHIZUKI KIMPO
Plate v

blue and red, purple (*murasaki*); yellow and black, dark green (*unguisu cha*); yellow and red, orange (*kaba*); black and red, brown (*tobiiro*); black and white, gray (*nezumiiro*). These secondary colors in combination produce other tones and shades required. Powdered gold and silver, and crimson made from the saffron plant are also employed. The colors, excepting yellow, are prepared for use by mixing them with light glue upon a saucer. With yellow, water alone is used. In addition to all the foregoing there are other expensive colors used in careful work and known as mineral earths (*iwamono*). They are blue (GUNJO), dark or Prussian blue (KONJO), light bluish-green (GUNROKU), green (ROKUSHO), light green (BYAKUGUN), pea green (CHA-ROKU SHO) and light red (SANGO MATSU). Parent Colors and Their Combinations

The use of primary colors in a painting in proximity to secondary ones originated by them is to be avoided, as both lose by such contrast; and when a color-scheme fails to give satisfaction it will usually be found that this cardinal principle of harmony, called *iro no kubari*, has been disregarded by the artist. Color in art is the dress, the apparel in which the work is clad. It must be suitably combined, restrained, and attract no undue attention (*medatsunai*). True color sense is a special gift. Color Harmony

LAWS GOVERNING
THE CONCEPTION AND EXECUTION
OF A PAINTING

Proportion
and Design
(ICHI and ISHO)

WHEN a Japanese artist is preparing to paint a picture he considers first the space the picture is to occupy and its shape, whether square, oblong, round or otherwise; next, the distribution of light and shade, and then the placing of the objects in the composition so as to secure harmony and effective contrasts. In settling these questions he relies largely on the laws of proportion and design.

The principles of proportion (ICHI) and design (ISHO) are closely allied. They aim to supply and express with sobriety what is essential to the composition, proportion determining the just arrangement and distribution of the component parts, and design the manner in which the same shall be handled. In a landscape, proportion may require the balancing effect of buildings and trees, while design will determine how the same may be picturesquely presented; for instance, by making the

[46]

trees partially hide the buildings, thus provoking a desire to see more than is shown. Such suggestion or stimulation of the imagination is called YUKASHI. The Japanese painter is early taught the value of suppression in design—*l'art d'ennuyer est de tout dire.*

A well-known rule of proportion, quaintly expressed in the original Chinese and which is more or less adhered to in practice, requires in a landscape painting that if the mountain be, for example, ten feet high the trees should be one foot, a horse one inch and a man the size of a bean. JO SAN SEKI JU, SUN BA TO JIN (Plate XVII).

Design, called in art ISHO ZUAN or *takumi*, is largely the personal equation of the artist. It is his power of presenting and expressing what he treats in an original manner. The subject may not be new, but its treatment must be fresh and attractive. Much will depend upon the learning and the technical ability of the artist. In the matter of design the artists of Tokyo have always differed from those of Kyoto, the former aiming at lively and even startling effects, while the latter seek to produce a quieter or more subdued (*otonashi*) result.

Where landscapes or trees are to be painted upon a single panel, panels on each side of it may be conveniently placed and the painting designed upon the central panel in connection with the two additional ones used for elaboration. In this way, when the side panels are withdrawn the effect is as though such landscape or trees were seen

[47]

Proportion
and Design
(ICHI and ISHO) through an open window, and all cramped or forced appearance is avoided. The *Ukiyo e* artists practiced a similar method in their *hashirakake* or long, narrow, panel-like prints of men and women used for decorating upright beams in a room.

The literature of art abounds in instances illustrative of correct proportion and design.

The artist Buncho being requested to paint a crow flying across a *fusuma* or four sliding door-like panels, after much reflection painted the bird in the act of disappearing from the last of these sub-divisions, the space of the other three suggesting the rapid flight which the crow had already accomplished, and the law of proportion (ICHI) or orderly arrangement thus observed was universally applauded.

In the wooded graveyard of the temple at Ike-gami, where the tombs of so many of the Kano artists (including Tanyu) are to be found, is a stone marking the grave of a Kano painter who, having executed an order for a picture and his patron observing that it was lacking in design and that he must add a certain gold effect in the color scheme, rather than violate his own convictions of what he considered proper design, first refused to comply and then committed *hara kiri*.

Contrast
(IN YO) A canon of Japanese art which is at the base of one of the peculiar charms of Japanese pictures, not merely in the whole composition but also in minute details that might escape the attention at first glance, requires that there should be in every

[48]

painting the sentiment of active and passive, light and shade. This is called IN YO and is based upon the principle of contrast for heightening effects. The term IN YO originated in the earliest doctrines of Chinese philosophy and has always existed in the art language of the Orient. It signifies darkness (IN) and light (YO), negative and positive, female and male, passive and active, lower and upper, even and odd. This term is of constant application in painting. A picture with its lights and shades properly distributed conforms to the law of IN YO. Two flying crows, one with its beak closed, the other with its beak open; two tigers in their lair, one with the mouth shut, the other with the teeth showing; or two dragons, one ascending to the sky and the other descending to the ocean, illustrate phases of IN YO. Mountains, waves, the petals of a flower, the eyeball of a bird, rocks, trees—all have their negative and positive aspects, their IN and their YO. The observance of this canon secures not only the effective contrast of light and shade in a picture but also an equally striking contrast between the component parts of each object composing it.

Contrast (IN YO)

The law of form, in art called KEISHO or KAKKO, is widely applied for determining not only the correct shape of things but also their suitable or proper presentation according to circumstances. It has to do with all kinds of attitudes and dress. It determines what is suitable for the prince and for the beggar, for the courtier and for the peasant. It regulates the shape that objects should take

Form (KEISHO)

[49]

Form (KEISHO) according to conditions surrounding them, whether seen near or far off, in mist or in rain or in snow, in motion or in repose. The exact shape of objects in motion (as an animal running, a bird flying or a fish swimming) no one can see, but the painter who has observed, studied and knows by heart the form or shape of these objects in repose can, by virtue of his skill, reproduce them in motion, foreshortened or otherwise; that is KEISHO; and he is taught and well understands that if in executing such work his memory of essential details fails him hesitancy is apt to cause the picture to perish as a work of art.

KEISHO literally means shape, but in oriental art it signifies also the proprieties; it is a law which enforces among other things canons of good taste and suppresses all exaggerations, inartistic peculiarities and *grimaces*.

Laws for Painting Historical Subjects (KO JUTSU) The law touching historical subjects and the manner of painting them is called KO JUTSU. Special principles apply to this department of Japanese art. The historical painter must know all the historical details of the period to which his painting relates, including a knowledge of the arms, accoutrements, costumes, ornaments, customs and the like. This subject covers too vast a field and is too important to be summarily treated here. Suffice it to say that there have been many celebrated historical painters in Japan. I recall, on the other hand, a picture once exhibited by a distinguished Tokyo artist which was superbly executed but wholly ignored by the jury because it violated some canon applicable to historical painting.

[50]

The term YU SHOKU refers to the laws governing the practices of the Imperial household, Buddhist and Shinto rites. Before attempting any work of art in which these may figure the painter must be thoroughly versed in the appointments of palace interiors, the rules of etiquette, the occupations and pastimes of the Emperor, court nobles (*Kuge*), *daimyo* and their military attendants (*samurai*), the costumes of the females (*tsubone*) of the Imperial household and their duties and accomplishments. The Tosa school made a thorough familiarity with such details its specialty. All Buddhist paintings come under the law of YU SHOKU.

Laws for Painting Rites and Ceremonies

Let us next consider briefly some of the principles applicable to Japanese landscape painting. Landscapes are known in art by the term SAN SUI, which means mountain and water. This Chinese term would indicate that the artists of China considered both mountains and water to be essential to landscape subjects, and the tendency in a Japanese artist to introduce both into his painting is ever noticeable. If he cannot find the water elsewhere he takes it from the heavens in the shape of rain. Indeed, rain and wind subjects are much in favor and wonderful effects are produced in their pictures suggesting the coming storm, where the wind makes the bamboos and trees take on new, weird and fantastic shapes.

Laws for Landscape Painting (SAN SUI)

The landscape (Plate XVIII) contains a lofty mountain, rocks, river, road, trees, bridge, man, animal, et cetera. The first requisite in such a composition is that the picture respond to the law

Heaven, Earth, Man (TEN, CHI, JIN)

[51]

of TEN CHI JIN, or heaven, earth and man. This

wonderful law of Buddhism is said to pervade the universe and is of widest application to all the art of man. TEN CHI JIN means that whatever is worthy of contemplation must contain a principal subject, its complimentary adjunct, and auxiliary details. Thus is the work rounded out to its perfection.

This law of TEN CHI JIN applies not only to painting but to poetry (its elder sister), to architecture, to garden plans, as well as to flower arrangement; in fact, it is a universal, fundamental law of correct construction. In Plate XVIII the mountain is the dominant or principal feature. It commands our first attention. Everything is subservient to it. It, therefore, is called TEN, or heaven. Next in importance, complimentary to the mountain, are the rocks. These, therefore, are CHI, or earth; while all that contributes to the movement or life of the picture, to wit, the trees, man, animal, bridge and river, are styled JIN, or man, so that the picture satisfies the first law of composition, namely, the unity in variety required by TEN CHI JIN.

There is another law which determines the gen-
eral character to be given a landscape according to the season, and is thus expressed: Mountains in spring should suggest joyousness; in summer, green and moisture; in autumn, abundance; in winter, drowsiness. The formula runs as follows: SHUNZAN, *warau gotoshi;* KAZAN, *arau gotoshi;* SHUZAN, *yoso gotoshi;* TOZAN, *nemuru gotoku.*

[52]

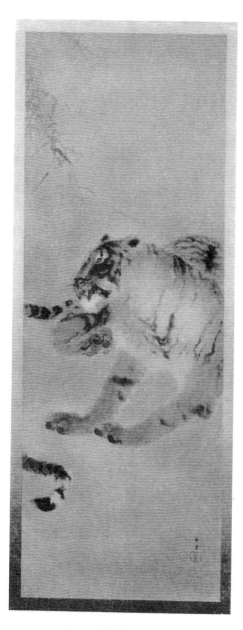

TIGER
BY KISHI CHIKUDO
Plate VI

Similarly, according to the season, there are four principal ways of painting bamboo (CHIKU). In fair-weather bamboo (SEI CHIKU) the leaves are spread out joyously; in rainy-weather bamboo (UCHIKU) the leaves hang down despondently; in windy-weather bamboo (FUCHIKU) the leaves cross each other confusedly, and in the dew of early morning (ROCHIKU) the bamboo leaves all point upwards vigorously (Plate LIII a 1 to a 4). ^{The Four Seasons (SHI KI NO SAN SUI)}

The Kano artists differ from the Shijo painters in their manner of combining (*kasaneru*) the leaves and branches of the bamboo. Speaking generally, the Shijo artists point the leaves downward, while the former point them upward, which is more effective.

Again, in snow scenery the Kano artists first paint the bottom of the snow-line and then by shading (*kumadori*) above the same with very light ink (*usui sumi*) produce the effect of accumulated snow. The Okyo school secures the same result in a much more brilliant manner, using but a single dexterous stroke of the well-watered brush, the point only of which is tipped with *sumi*.

Some artists, notably Kubota Beisen and his followers, employ both methods, the former for near and the latter for distant snow landscapes.

Low mountains in a landscape suggest great distance. Fujiyama, the favorite subject of all artists, should not be painted too high, else it loses in dignity by appearing too near. In an art work written by Oishi Shuga, Fuji is reproduced as it appears at every season of the year, whether clad in snow, partly concealed by clouds, or plainly vis-

[53]

ible in unobstructed outline. The book is a safe guide for artists to consult.

Laws for Ledges (SHUN PO) We may next consider some laws applicable to mountains, rocks and ledges. It has long since been observed by the great writers on art in China that mountains, rocks, ledges and peaks have certain characteristics which distinguish them. These differ not only with their geological formations but also vary with the seasons on account of the different grasses and growths which may more or less alter or conceal them. To attempt to reproduce them as seen were a hopeless task, there being too much confusing detail; hence, salient features only are noted, studied and painted according to what is called SHUN PO, or the law of ledges or stratifications. There are eight different ways in which rocks, ledges and the like may be represented:

The peeled hemp-bark method, called HI MA SHUN (Plate XXIII a).

The large and small axe strokes on a tree, called DAI SHO FU HEKI SHUN (Plate XXIII b).

The lines of the lotus leaf, called KA YO SHUN (Plate XXIV a).

Alum crystals, called HAN TO SHUN (Plate XXIV b).

The loose rice leaves, called KAI SAKU SHUN (Plate XXV a).

Withered kindling twigs, called RAN SHI SHUN (Plate XXV b).

Scattered hemp leaves, termed RAMMA SHUN (Plate XXVI a).

The wrinkles on a cow's neck, called GYU MO SHUN (Plate XXVI b).

[54]

CONCEPTION AND EXECUTION

These eight laws are not only available guides to desired effects; they also abbreviate labor and Laws for Ledges (SHUN PO) save the artist's attempting the impossible task of exactly reproducing physical conditions of the earth in a landscape painting. They are symbols or substitutes for the truth felt. Nothing is more interesting than such art resources whereby the sentiment of a landscape is reproduced by thus suggesting or symbolizing many of its essential features.

It was a theory of the great Chinese teacher, Chinanpin's Theory Chinanpin, and particularly enforced by him, that trees, plants and grasses take the form of a circle, called in art RIN KAN (see Plate xxvii), No. 1; or a semi-circle (HAN KAN) (Plate xxvii), No. 2; or an aggregation of half-circles, called fish scales (GYO RIN) (Plate xxvii), No. 3; or a modification of these latter, called moving fish scales (GYO RIN KATSU HO) (Plate xxvii), No 4. Developing this principle on Plate xxviii, No. 1, we have theoretically the first shape of tree growth and on Plate xxviii, No. 2, the same practically interpreted. In Nos. 3 and 4, same plate, we have the growth of grass illustrated theoretically and practically. In Plate xxix, according to this method, is constructed the entire skeleton of a forest tree. In Nos. 1 and 2 on this plate numerous small circles are indicated. These show where each stroke of the brush begins, the points of commencement being of prime importance to correct effect. In No. 3, same plate, we have the foundation work of a tree in a Japanese painting. It is needless to point out the marvelous vigor

[55]

apparent in work constructed according to the
Chinanpin's Theory above principles.

In the painting of rocks, ledges, and the like, Chinanpin taught that the curved lines of the fish scales are to be changed into straight lines, three in number, of different lengths, two being near together and the third line slightly separated, and all either perpendicular or horizontal, as in Plate xxx, Nos. 1 and 2. In the same plate, Nos. 3 and 4, we have the principle of rock construction illustrated. In Plate xxxi, Nos. 1, 2 and 3, is seen the practical application of this theory to *kake-mono* work. In executing these lines for rocks much stress is laid upon the principle of IN YO; on the elevated portions the brush must be used lightly (IN) and on the lower portions it must be applied with strength (YO). At the bottom, where grass, mould, and moss accumulate, a rather dry brush (KWAPPITSU) is applied with a firm stroke.

Next, there are laws for near and distant tree, shrubbery and grass effects, corresponding to the
Dots (TEN PO) season of the year. These are known as the laws of dots (TEN PO); the saying TEN TAI SAN NEN indicates that it takes three years to make them correctly.

They are as follows:

The drooping wistaria dot (SUI TO TEN) (Plate xxxii a) for spring effects.

The chrysanthemum dot (KIKU KWA TEN) (Plate xxxii b) used in summer foliage.

The wheel spoke dot (SHA RIN SHIN) (Plate xxxiii a), being the pine-needle stroke and used for pine trees.

The Chinese character for the verb "to save" (KAI JI TEN) (Plate xxxiii b), used for both trees and shrubbery. Dots (TEN PO)

The pepper dot (KO SHO TEN) (Plate xxxiv a). This dot requires great dexterity and free wrist movement. It will be observed that the dots are made to vary in size but are all given the same direction.

The mouse footprints (SO SOKU TEN) (Plate xxxiv b), used for cryptomeria and other like trees.

The serrated or sawtooth dot (KYO SHI SHIN) (Plate xxxv a), much used for distant pine-tree effects.

The Chinese character for "one" (ICHI JI TEN) (Plate xxxv b). The effect produced by this character is very remarkable in representing maple and other trees whose foliage at a distance appears to be in layers.

The Chinese character for "heart" (SHIN), called SHIN JI TEN (Plate xxxvi a). This is used most effectively for both foliage and grasses.

The Chinese character for "positively" (HITSU), called HITSU JI TEN (Plate xxxvi b). This dot or stroke is successfully employed in reproducing the foliage of the willow tree in spring.

The rice dot, called BEI TEN (Plate xxxvii a).

The dot called HAKU YO TEN (Plate xxxvii b), being smaller than the pepper dot, with the clove dot (SHO JI TEN) surrounding it.

It is a strictly observed rule that none of these dots should interfere with or hide the branches of the trees of which they form part.

The term *chobo chobo* is applied to the practice of always finishing a landscape painting, rocks,

[57]

trees or flowers, with certain dots judiciously added
Dots
(TEN PO) to enliven and heighten the general effect. These
dots, done with a springing wrist movement, serve
to enliven the work and give it freshness, just as a
rain shower affects vegetation. The Kano artists
were most insistent upon *chobo chobo*.

There are many quaint aids to artistic effects
from time immemorial well known to and favored
by the old Chinese painters and still successfully
practiced in Japan. Probably the larger number of
these are employed in the technical construction
of the Four Paragons (p. 66 *et seq.*). There are
still others: as, for instance, the fish-scale pattern
(Plate xix), used in painting the clustered needles
of the pine tree or the bending branches of the
willow; the stork's leg for pine tree branches (Plate
xix); the gourd for the head and elongated jaws of
the dragon; the egg for the body of a bird (Plate
xxii; the stag horn for all sorts of interlacing
branches; the turtle back pattern or the dragon's
scales for the pine tree bark. In addition to these,
the general shapes of certain of the Chinese written
characters are invoked for reproducing winding
streams (Plate xx), groupings of rocks, meadow,
swamp, and other grasses and the like.

Of course the exact shape of the various Chinese
characters here referred to must not be actually
painted into the composition but merely the senti-
ment of their respective forms recalled. They are
simply practical memory aids to desired effects.

It is the spirit of the character rather than its
exact shape which should control; the order of

the painted strokes being that of the written char- acter, its sentiment or general shape is thus repro- duced.

In this connection I would allude to criticisms or judgments upon Japanese painting in which particular stress is laid upon its calligraphic quality. If any Japanese artist was seriously informed that his method of painting was calligraphic, he would explode with mirth. There are several ways to account for this rather wide-spread error. Much that is written about Japanese painting and its calligraphy is but the repetition by one author of what he has taken on trust from another, an effective way sometimes of spreading misinformation. It is quite true that the assiduous study of Chinese writing (sho) is an essential part of thorough art education in Japan, not, however, for the purpose of learning to paint as one writes, or of introducing written characters more or less transformed into a painting (if that be what is meant by "calligraphic"), but simply to give the artist freedom, confidence, and grace in the handling of the brush and to train his eye to form and balance and to acquire both strength of stroke and a knowledge of the sequence of strokes. To write in Chinese after the manner of professionals (sho ka) is truly a great art, esteemed even higher than painting; it requires thirty years of constant practice to become expert therein, and it has many laws and profound principles which, if mastered by artists, will enable them to be all the greater in their painting, and many Japanese artists have justly prided them-

[59]

selves upon being expert writers of the Chinese characters. Okyo practiced daily for three years the writing of two intricate characters standing for his name, until he was satisfied with their forms, but there is nothing calligraphic about any of Okyo's painting.

Possibly what has misled foreign critics and even some Japanese writers is that there exists a class of men in Japan given to learning, to writing, and also to painting in a particular way.

These men are called BUN JIN (literati) and their style of painting is called BUN JIN FU. They are not artists, but are known as Confucius' scholars (JU SHA), and being professional or trained writers in the difficult art of Chinese calligraphy they have a manner of painting strictly *sui generis*. It is known as the NAN GWA or southern literary way of painting. Their subjects are the bamboo, the plum, the orchid and the chrysanthemum, called the four paragons (SHI KUN SHI). These and land-scapes they paint with their writing brush and more or less in what is called the grass character (SO SHO) manner of writing. In fact, they often aim to make their painting look like writing and they rarely use any color except light-brown (TAI SHA). They suppress line as distinguished from mass. This method is called *bokkotsu* (see Plate XII). Such painting of the NAN GWA school is, in a sense, calligraphic, but that is not the kind of painting which Japanese artists are taught, practice and profess, nor is it even recognized as an art, but simply as an eccentric development of the literary

man with a taste for painting. At one time or another well-known artists, especially at the begin- Japanese Art and Chinese ning of the Meiji era, have affected this BUN JIN Calligraphy style simply as a passing fashion.

One other possible explanation of the critics pronouncing all Japanese paintings calligraphic is that various Chinese characters are, as we have seen, invoked and employed by Japanese artists as memory aids to producing certain effects; but were these characters introduced calligraphically, the result would be laughable. It should be plain then that Japanese painting is not calligraphic; as well apply the term calligraphy to one of Turner's water colors. On the other hand, Chinese writing is built up on word pictures. There are between five and six hundred mother characters, all imitating the shapes of objects; these, with their later combinations, constitute the Chinese written system, so that while there is nothing calligraphic about Japanese painting, there is much that is pictorial about Chinese calligraphy.

Other landscape laws applicable to things seen at a distance in a painting require that distant trees should show no branches nor leaves; people at a distance, no features; distant mountains, no ledges; distant seas or rivers, no waves. Again, clouds should indicate whence they come; running water the direction of its source; mountains, their chains; and roads, whither they lead.

In regard to painting moving waters, whether Laws of deep or shallow, in rivers or brooks, bays or oceans, Moving Waters Chinanpin declared it was impossible for the eye

[61]

to seize their exact forms because they are ever changing and have no fixed, definite shape, therefore they can not be sketched satisfactorily; yet, as moving water must be represented in painting, it should be long and minutely contemplated by the artist, and its general character—whether leaping in the brook, flowing in the river, roaring in the cataract, surging in the ocean or lapping the shore— observed and reflected upon, and after the eye and memory are both sufficiently trained and the very soul of the artist is saturated, as it were, with this one subject and he feels his whole being calm and composed, he should retire to the privacy of his studio and with the early morning sun to gladden his spirit there attempt to reproduce the movement of the flow; not by copying what he has seen, for the effect would be stiff and wooden, but by symbolizing according to certain laws what he feels and remembers.

In work of this kind there are certain directions for the employment of the brush which can only be learned from oral instruction and demonstration by the master.

In Plate xxxviii a, 1, the method by which waves are reproduced is shown, the circles indicating where the brush is turned upon itself before again curving. On the same plate (b) waveless water, shallow water, and river water with current are indicated at the top, middle and bottom, respectively. In Plate xxxix a, we have the moving waters of an inland sea; in b, the bounding waters of a brook; in Plate xl the stormy waves of the ocean.

[62]

Conception and Execution

We will now consider another unique department of Japanese painting in connection with the garments of human beings. The lines and folds of the garment may be painted in eighteen different ways according to what are known as the eighteen laws for the dress (EMON JU HACHI BYO). I will mention each of these laws in its order and refer to the plate illustrations of the same.

The floating silk thread line (KOU KO YU SHI BYOU) (Plate XLI upper). This line was introduced by the Tosa school of artists eight hundred years ago and has been in favor ever since. It is the purest or standard line and is reserved for the robes of elevated personages. The brush is held firmly and the lines, made to resemble silk threads drawn from the cocoon, are executed with a free and uninterrupted movement of the arm.

The Koto string line (KIN SHI BYOU) (Plate XLI lower). This is a line of much dignity and of uniform roundness from start to finish. It is produced by using a little more of the tip of the brush than in the silk thread line and there must be no break or pause in it until completed. This line is used for dignified subjects.

Chasing clouds and running water lines (KOU UN RYU SUI BYOU) (Plate XLII upper). These are produced with a wave-like, continuous movement of the brush—breathing, as it were. Such lines are generally reserved for the garments of saints, young men and women.

The stretched iron wire line (TETSU SEN BYOU) (Plate XLII lower). This is a very important line,

[63]

much employed by Tosa artists and used for the formal, stiffly starched garments of court nobles, *samurai,* NO dancers, and umpires of wrestling matches. When this line is painted the artist must have the feeling of carving upon metal.

The nail-head and rat-tail line (TEI TOU SOBI BYOU) (Plate XLIII upper). In making this, the stroke is begun with the feeling of painting and reproducing the hard nature of a tack and then continued to depict a rat's tail, which grows small by degrees and beautifully less.

The line of the female court noble or *tsubone* (SOU I BYOU) (Plate XLIII lower). This line and the preceding are much used for the soft and graceful garments of young men and women and have always been favorites with the *Ukiyo e* painters.

The willow-leaf line (RYU YOU BYOU) (Plate XLIV upper). This line has always been in great favor with all the schools, and especially with the Kano painters, and is used indiscriminately for goddesses, angels, and devils. It is intended to reproduce the sentiment of the willow leaf, commencing with a fine point, swelling a little and again diminishing.

The angleworm line (KYU EN BYOU) (Plate XLIV lower). The angleworm is of uniform roundness throughout its length and it is with that sentiment or *kokoromochi* that it must be painted, care being taken to conceal the point of the brush along the line. This is a most important line in all color painting. Indeed, where much pains are to be taken with the picture, and the colors are to be most carefully laid on, it is the best and favorite line.

[64]

CONCEPTION AND EXECUTION

The rusty nail and old post line (KETSU TOU TEI BYOU) (Plate XLV upper). This line is painted with a brush, the point of which is broken off. The Kano school of artists particularly affect this method of line painting in depicting beggars, hermits, and other such characters.

The date seed line (SAU GAI BYOU) (Plate XLV lower). This line, intended to represent a continuous succession of date seeds, is made with a throbbing brush and generally used in the garments of sages and famous men of learning.

The broken reed line (SETSU RO BYOU) (Plate XLVI upper) is made with a rather dry brush and, as its name indicates, should be painted with the feeling of reproducing broken reeds. It is a line intended to inspire terror, awe, consternation, and is used for war gods, FUDO *sama*, and other divinities.

The gnarled knot line (KAN RAN BYOU) (Plate XLVI lower). In this kind of painting the brush is stopped from time to time and turned upon itself with a feeling of producing the gnarled knots of a tree. The line is much used for ghosts, dream pictures, and the like.

The whirling water line (SEN PITSU SUI MON BYOU) (Plate XLVII upper) is used for rapid work and reproduces the swirl of the stream. It was a favorite line with Kyosai.

The suppression line (GEN PITSU BYOU) (Plate XLVII lower) is suitable where but few lines enter into the painting of the dress. Any of the other seventeen lines can be employed in this way. The Kano artists used it a great deal.

[65]

Dry twig or old firewood line (KO SHI BYOU) (Plate XLVIII upper) is generally used in the robes of old men and produced by what is called the dry brush; that is, a brush with very little water mixed with the *sumi*. The stroke must be bold and free to be effective.

The orchid leaf line (RAN YAU BYOU) (Plate XLVIII lower). This is a very beautiful method of painting whereby the graceful shape of the orchid leaf is recalled; the line is used for the dresses of *geishas* and beauties (*bijin*) generally.

The bamboo leaf line (CHIKU YAU BYOU) (Plate XLIX upper). This style of painting, which aims at suggesting the leaf of the bamboo, was much in favor formerly in China. Japanese artists seldom employ it.

The mixed style (KON BYOU) (Plate XLIX lower), in which any of the foregoing seventeen styles can be employed provided the body of the garment be laid on first in mass and the lines painted in afterward while the *sumi* or paint is still damp. This gives a satiny effect.

There are many other ways of painting the lines of the garment but the preceding eighteen laws give the strictly classic methods known to oriental art.

The orchid, bamboo, plum, and chrysanthemum (RAN CHIKU BAI KIKU) are called in art the Four Paragons. Although these may be the first studies taught they are generally the last subjects mastered. Much learning and research have been expended upon them in China and Japan. An

artist who can paint SHI KUN SHI is a master of the brush. I will indicate some of the laws applicable to each of these subjects.

The orchid grows in the deepest mountain recesses, exhaling its perfume and unfolding its beauty in silence and solitude, unheralded and unseen; thus, regardless of its surroundings and fulfilling the law of its being, fifteen hundred years ago it was proclaimed by the poet and painter San Koku to typify true nobility and hence was a paragon. In poetry it is called the maiden's mirror. Many great Chinese writers have taken the orchid (RAN) for their nom de plume, as Ran Ya, Ran Tei, Ran Kiku, and Ran Ryo. *The Orchid (RAN)*

Plate LII shows an orchid plant in flower. The established order of the brush strokes for the leaves is indicated at the tips by numerals one to eleven; that of the flower stalk and flower by numbers twelve to twenty-one. Various forms are invoked in painting both the plant and the flower and are more or less graphically suggested. These forms are indicated by numbers, as follows: *Technique of Orchid Painting*

Leaf blade No. 1 reproduces twice the stomach of the mantis (22), the tail of the rat (23), with the cloud longing (BO UN) of the tip (24). Leaf No. 2 is similarly constructed but is painted to intersect leaf No. 1, leaving between them a space (No. 25) called the elephant's eye. Leaf No. 3 is intersected by leaf No. 4, enclosing another space between them, known as the eye of the phœnix. Adding leaves Nos. 5 and 6, called SEKI or *kazari*, meaning ornament, we have the most essential

[67]

parts of the orchid plant. Leaf No. 7 is known as the rat's tail and leaf No. 8 as the body of a young carp. Nos. 9, 10 and 11 are called nail heads, from their fancied resemblance to such objects. With these the plant is structurally complete.

The flower stalk is divided into four parts (Nos. 12 to 15), called rice sheaths. The flower is made with six strokes (16 to 21), called the flying bee (26). The three dots in the flower reproduce the sentiment of the Chinese character for heart (23).

The orchid is variously painted rising from the ground, issuing from the banks of a brook, or clinging with its roots to a rocky cliff. In allusion to the lonely places where it grows it is called *I shiri no kusa* or the plant which the wild boar knows. The orchid is credited with medicinal properties, and the flower steeped in wine makes a potion which secures perpetual health. The charm of friendship is likened unto the orchid's perfume and the flowers are worn by the ladies of the court to ward off maladies.

The leaves of the bamboo are green at all seasons. The stems are straight and point upwards. The plant is beautiful under all conditions—struggling beneath the winter snow or fanned by the spring breeze, swaying with the storm or bending under showers—its grace challenges admiration. Typifying constancy and upright conduct, it was claimed over a thousand years ago by Shumo Shiku to be a paragon.

Nothing is more difficult to paint correctly than this plant. Plate LIII shows the bamboo with its

[68]

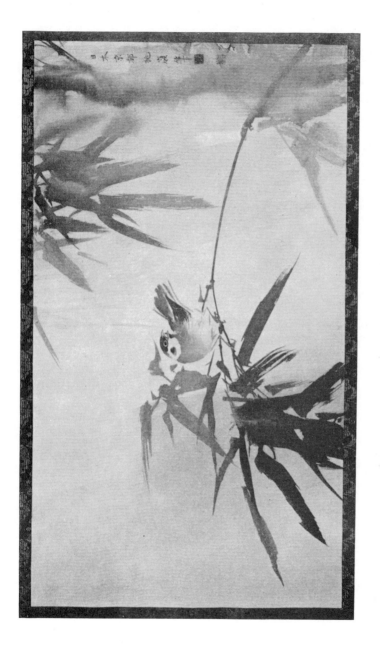

Bamboo, Sparrow and Rain
By Torei Nishigawa
Plate VII

essentially component parts and forms indicated as follows: The upright stalk is in five subdivisions (1 to 5), each differing in length but all suggesting the Chinese character for one (ICHI) painted upright. These are separated from each other by strokes reproducing the Chinese characters for positively (22), for heart (23), for second (24), for one (25), and for eight (26). The stem (6 to 10) is composed of rats' tails. The manner of painting and combining the leaves of the bamboo is called *take no ha no kumitata* and is minutely described and illustrated in Ransai's great work, *Gwa Fu*. The essentials are: The five-leaf arrangement (GO YO) (11 to 15) with the ornament (16), called *kazari*. The three-leaf arrangement (17 to 19) called KO JI, from its resemblance to the Chinese character KO (32). The two-leaf arrangement (20 and 21) called JIN JI, from its resemblance to the character JIN (33), a man. In further development of the plant the following imitative arrangements of the leaves are used: The fish tail (GYO BI) (27), the goldfish triple tail (KINGYO BI) (28), the swallow tail (EN BI) (29), the Chinese character for bamboo (CHIKU JI) (30), and the seven-leaf arrangement (SHICHI YO) (31). It will be observed how the odd or positive numbers (YO) are favored. The foregoing method is used by the Okyo painters.

The Kano artists have another system for combining and elaborating the leaf growth, but it does not differ radically from that here given. The leaf of the bamboo reproduces the shape of a carp's body (34). It also resembles the tail feathers of the

[69]

phœnix. An oil is made from the bamboo and is said to be good for people with quick tempers. Many artists adopt the name of bamboo for their nom de plume; witness, Chiku Jo, Chiku Do, Chiku Sho, Chiku Den and the like.

It is said that the full moon casts the shadow of the bamboo in a way no other light approaches. The learned Okubu Shibutsu first observed this and the discovery led to his becoming the greatest of all bamboo painters. Nightly he used to trace with *sumi* such bamboo shadows on his paper window. Sho Hin, a lady artist of Tokyo, enjoys a well-earned reputation for painting bamboo. She was a pupil of Tai Zan, a Kyoto representative of the Chinese school. The Kano painters much favored the subject of the seven sages in the bamboo grove. Bamboo grass (SASSA) is much painted by all the schools. It is very decorative. There is a male and a female bamboo; from the latter (*medake*) arrows are made. The uses to which man puts the bamboo are surprisingly numerous, thus fortifying its claims to be regarded a paragon.

The plum is the first tree of the year to bloom. It has a delicate perfume. Though the trunk of the tree grows old it renews its youth and beauty every spring with vigorous fresh branches crowded with buds and blossoms. In old age the tree takes on the shape of a sleeping dragon. With no other flower or tree are associated more beautiful and pathetic folk-lore and historical facts. For these and other reasons Rennasei assigned to the plum its place as a paragon centuries and centuries ago.

[70]

The tree branches with their interlacings reproduce the spirit of the Chinese character for woman, called JO JI (Plate L, No.1). The blossom (2) is painted on the principle of IN YO, the upper portion of the petal line being the positive or YO and the lower being the negative or IN side. This is repeated five times for the five petals of the blossom (3). The stamens (4) and pistils are reproductions of the Chinese character SHO, meaning small. For the calyx (5) the Chinese character for clove (CHO) is invoked.

Technique of Plum Painting

The great scholar and nobleman, Sugewara Michizane, particularly loved the plum tree. Banished from his home, as he was leaving his grounds he addressed that silent sentinel of his garden in the following verse, which has earned immortality:

Do thou, dear plum tree, send out thy perfume when
 the east wind blows;
 And, though thy master be no longer here,
Forget not to blossom always when the springtime comes.

In Japan the plum, though not eaten raw, when salted has wonderful strength sustaining properties, and in wartime supplies as *ume boshi* a valuable concentrated food.

The chrysanthemum has been cultivated in China for four thousand years and its fame was sung by the poet and scholar, To En Mei, who prized it above all else under heaven and assigned it the rank of paragon.

The Chrysanthemum (KIKU)

When all Nature is preparing for the long sleep of winter and the red, brown and golden forest leaves are dropping, spiritless, to the ground, the

[71]

The Chrysan-
themum (KIKU) chrysanthemum comes forth from the earth in
fresh and radiant colors. It gladdens the heart in
the sad season of autumn. Its clustered petals, all
united and never scattering, typify the family, the
State, and the Empire. For the last six hundred
years the sixteen-petaled chrysanthemum has been
the emblem of Imperial sovereignty in Japan.
With artists it has always been a favorite flower
subject. There are innumerable ways of painting it.

Technique of
Chrysanthe-
mum
Painting Plate LI shows the chrysanthemum flower and
leaves painted in the Okyo manner. There is an
established order in which the leaves must be exe-
cuted. Viewed from the front (Nos. 1 and 2) the
order of the brush stroke is as indicated on the plate;
viewed from the side the brush is applied in the
order indicated in Nos. 4 and 5. The flower (6 and 7)
is built up from the bud (5), petals being added
according to the effect sought. The flower half
opened is shown in No. 6, and wholly opened in
No. 7. The calyx somewhat reproduces the Chi-
nese written character CHO. The Kano painters
have a different way of painting the chrysanthe-
mum leaves and flowers, but the foregoing illus-
trates the general principles obtaining in all the
schools. Korin painted the KIKU in a manner quite
different from that of any other artist. The word
KIKU is Chinese, the Japanese word for the flower
being *kawara yomogi*. The Nagoya artists have
always been particularly skilful in painting the
chrysanthemum in an exceptionally engaging way.
The little marguerite-like blossom is called *mame-
giku,* and is a universal favorite among all artists.

[72]

CONCEPTION AND EXECUTION

The impression produced on one who for the first time hears enumerated these various laws may The Value of These Laws possibly be that all such methods for securing artistic effects are arbitrary, mechanical and unnatural. But in practice, the artist who invokes their aid finds they produce invariably pleasing and satisfactory results. It must not be supposed that such laws are exclusive of all other methods of painting in the Japanese style. On the contrary the artist is at liberty to use any other method he may select provided the result is artistically correct. Many painters have invented methods of their own which are not included in the foregoing enumeration of these laws of lines, dots and ledges, which, it must always be borne in mind, are only to assist the artist who may be in doubt or difficulty as to how he shall best express the effect he aims at. It is such second nature for him to employ them that he does so as unconsciously as one in writing will invoke the rules of grammar. It is related that a great statesman, being asked if it were necessary for a diplomat to know Latin and Greek, replied that it was quite sufficient for him to have forgotten them. And so with these laws. A knowledge of them is a necessary part of the education of every Japanese artist, for they lie at the very foundation of the art of oriental painting. Chinese writing abounds with similar principles; it is a law applicable to one kind of such writing, called REI SHO, that in each character there shall be one stroke which begins with the head of a silkworm and terminates with a goose's tail. This also may

[73]

sound odd and seem forced, yet this law gives a The Value of
These Laws special and wonderful *cachet* to the character so written.

Some acquaintance with these principles and methods invoked by artists adds much to our keen enjoyment of their work, just as an analysis of the chords in a musical composition increases our pleasure in the harmonies they produce. Ruskin has discovered in the very earliest art the frequent use of simple forms suggested by the slightly curved and springing profile of the leaf bud which, he declares, is of enormous importance even in mountain ranges, when not vital but falling force is suggested. "This abstract conclusion the great thirteenth century artists were the first to arrive at" (Ruskin's Mod. Painters, Vol. III), and even in the architecture of the best cathedrals that author detects the observance of the law determining in an ivy leaf the arrangement of its parts about a center.

In Japanese art simple forms supplied by nature are often used for suggesting other forms as, for instance, the stork's legs for the pine tree branches, the turtle's back for the pine bark lines, the fish tail for bamboo leafage, the elephant's eye in the orchid plant, the shape of Fujiyama for the forehead of a beautiful woman, and various Chinese characters, originally pictorial, adumbrated in trees, flowers and other subjects. The universality of such underlying type forms recognized and applied by oriental artists is confirmatory of the principle that in both nature and art all is united by a common

[74]

chain or *commune vinculum* attesting the harmony between created things. A Japanese painting executed with the aid of such resources teems with vital force and suggestion, and to the eye of a connoisseur (*kuroto*) becomes a breathing microcosm.

To give some idea of the order in which the component parts of an object are painted according to Japanese rules, which are always stringently insisted upon, flowers like the chrysanthemum and peony are begun at their central point and built up from within outwardly, the petals being added to increase the size as the flower opens. In a flower subject the blossoms are painted first; the buds come next; then the stem, stalks, leaves and their veinings, and lastly the dots called *chobo chobo*.

The established order for the human figure is as follows: Nose and eyebrows, eyes, mouth, ears, sides of the face, chin, forehead, head, neck, hands, feet, and finally the appareled body. In Japanese art the nude figure is never painted.

In a tree the order is trunk, central and side limbs (Plate XXI), branches and their subdivisions, leaves and their veinings, and dots.

In birds: The beak in three strokes (TEN, CHI, JIN), the eye, the head, the throat and breast, the back, the wings, the body, the tail, the legs, claws, nails and eyeball (Plate XXII).

In landscape work the general rule is to paint what is nearest first and what is farthest last. Kubota's method was to do all this rapidly and, if possible, with one dip of the well-watered brush into the *sumi*, so that as the *sumi* becomes gradually

diluted and exhausted the proper effect of fore-
ground, middle distance and remote perspective is
obtained.

In painting mountain ranges that recede one
behind the other the same process is followed, and
mountains as they disappear to the right or left of
the picture should tend to rise. This principle is
called BO UN or cloud longing.

It is useless here to enumerate the many faults
which art students are warned against committing.
Suffice it to say the number is enormous. Out of
many of the Chinese formulas I will give only one,
which is known as SHI BYO or the four faults, and
is as follows:

JA, KAN, ZOKU, RAI. JA refers to attempted orig-
inality in a painting without the ability to give it
character, departing from all law to produce some-
thing not reducible to any law or principle. KAN is
producing only superficial, pleasing effect without
any *power* in the brush stroke—a characterless
painting to charm only the ignorant. ZOKU refers
to the fault of painting from a mercenary motive
only,—thinking of money instead of art. RAI is
the base imitation of or copying or cribbing from
others.

CANONS OF
THE ÆSTHETICS OF JAPANESE
PAINTING

O NE of the most important principles in the art of Japanese painting—indeed, a funda- Living mental and entirely distinctive character- ^{Movement} istic—is that called living movement, SEI DO, or *kokoro mochi*, it being, so to say, the transfusion into the work of the felt nature of the thing to be painted by the artist. Whatever the subject to be translated—whether river or tree, rock or mountain, bird or flower, fish or animal—the artist at the moment of painting it must feel its very nature, which, by the magic of his art, he transfers into his work to remain forever, affecting all who see it with the same sensations he experienced when executing it.

This is not an imaginary principle but a strictly enforced law of Japanese painting. The student is incessantly admonished to observe it. Should his subject be a tree, he is urged when painting it to feel the strength which shoots through the branches

[77]

and sustains the limbs. Or if a flower, to try to feel the grace with which it expands or bows its blossoms. Indeed, nothing is more constantly urged upon his attention than this great underlying principle, that it is impossible to express in art what one does not first feel. The Romans taught their actors that they must first weep if they would move others to tears. The Greeks certainly understood the principle, else how did they successfully invest with imperishable life their creations in marble?

Living Movement (SEI DO)

In Japan the highest compliment to an artist is to say he paints with his soul, his brush following the dictates of his spirit. Japanese painters frequently repeat the precept:

Waga kokoro waga te wo yaku;
Waga te waga kokoro ni ozuru.

Our spirit must make our hand its servitor;
Our hand must respond to each behest of our spirit.

The Japanese artist is taught that even to the placing of a dot in the eyeball of a tiger he must first feel the savage, cruel, feline character of the beast, and only under such influence should he apply the brush. If he paint a storm, he must at the moment realize passing over him the very tornado which tears up trees from their roots and houses from their foundations. Should he depict the seacoast with its cliffs and moving waters, at the moment of putting the wave-bound rocks into the picture he must feel that they are being placed there to resist the fiercest movement of the ocean, while to the waves in turn he must give an irresistible power to carry all before them; thus, by

[78]

this sentiment, called living movement (SEI DO), reality is imparted to the inanimate object. This is one of the marvelous secrets of Japanese painting, handed down from the great Chinese painters and based on psychological principles—matter responsive to mind. Chikudo, the celebrated tiger painter (Plate VI), studied and pondered so long over the savage expression in the eye of the tiger in order to reproduce its fierceness that, it is related, he became at one time mentally unbalanced, but his paintings of tigers are inimitable. They exemplify SEI DO.

From what has been said it will be appreciated why, in a Japanese painting, so much value is attached to the strength with which the brush strokes are executed (*fude no chicara*), to the varying lights and shades of the *sumi* (BOKU SHOKU), to their play and sheen (*tsuya*), and to the manifestation of the artist's power according to the principle of living movement (SEI DO). In a European painting such considerations have no place.

An oil painting can be rubbed out and done over time and again until the artist is satisfied. A *sumi e* or ink painting must be executed once and for all time and without hesitation, and no corrections are permissible or possible. Any brush stroke on paper or silk painted over a second time results in a smudge; the life has left it. All corrections show when the ink dries.

Japanese artists are not bound down to the lit- eral presentation of things seen. They have a canon, called *esoragoto*, which means literally an

invented picture, or a picture into which certain
fictions are painted.

Invention
(ESORAGOTO)

Every painting to be effective must be *esoragoto;*
that is, there must enter therein certain artistic
liberties. It should aim not so much to reproduce
the exact thing as its sentiment, called *kokoro
mochi,* which is the moving spirit of the scene.
It must not be a facsimile.

When we look at a painting which pleases us
what is the cause or source of our satisfaction?
Why does such painting give us oftentimes more
satisfaction than the scene itself which it recalls? It
is largely because of *esoragoto* or the admixture of
invention (the artistic unreality) with the unartistic
reality; the poetic handling or treatment of what
in the original may in some respects be common-
place.

A correctly executed Japanese painting in *sumi,*
called *sumi e,* is essentially a false picture so far as
color goes, where anything in it not black is repre-
sented. Hence, *sumi* paintings of landscapes, flowers
and trees, are untrue as to color, and the art lies in
making things thus represented seem the opposite
of what they appear and cause the sentiment of
color to be felt through a medium which contains
no color. This is *esoragoto.*

It is related that Okubo Shibutsu, famous for
painting bamboo, was requested to execute a *kake-
mono* representing a bamboo forest. Consenting,
he painted with all his known skill a picture in
which the entire bamboo grove was in red. The
patron upon its receipt marveled at the extraordi-

[80]

nary skill with which the painting had been exe-
cuted, and, repairing to the artist's residence, he
said: "Master, I have come to thank you for the
picture; but, excuse me, you have painted the
bamboo red." "Well," cried the master, "in what
color would you desire it?" "In black, of course,"
replied the patron. "And who," answered the artist,
"ever saw a black-leaved bamboo?" This story well
illustrates *esoragoto*. The Japanese are so accus-
tomed to associate true color with what the *sumi*
stands for that not only is fiction in this respect
permissible but actually missed when not employed.

In a landscape painting effects are frequently in-
troduced which are not to be found in the scene
sketched. The false or fictitious is added to heighten
the effect. This is *esoragoto*—the privileged depart-
ure, the false made to seem true. In a landscape a
tree is often found to occupy an unfortunate place
or there is no tree where its presence would heighten
the effect. Here the artist will either suppress or
add it, according to the necessities of treatment.
Not every landscape is improved by trees or plan-
tations; nor, indeed, is every view containing trees a
type scene for landscape treatment. Hence, certain
liberties are conceded the artist provided only the
effect is pleasing and satisfactory and that no prob-
abilities seem violated. This is *esoragoto*. Horace
understood this and lays it down as a fundamental
principle in art: "*Quid libet audendi*." The artist
will oftentimes see from a point of view impossible
in nature, but if the result is pleasing the liberty
is accorded. Sesshu, one of the greatest landscape

[81]

Invention (ESORAGOTO) painters of Japan, on returning to his own country after having studied some years in China, made a painting of his native village with its temple and temple groves, winding river and pagoda or five-roofed tower. His attention being subsequently called to the fact that in this village there was no tower or pagoda, he exclaimed that there ought to be one to make the landscape perfect, and thereupon he had the tower constructed at his own expense. He had painted in the pagoda unconsciously. This was *esoragoto*.

Spiritual Elevation (KI IN) There are no people in the world who have a higher idea of the dignity of art than the Japanese and it is a principle with them that every painting worthy of the name should reflect that dignity, should testify to its own worth and thus justly impress with sentiments of admiration those to whom it may be shown. This intrinsic loftiness, elevation or worth is known in their art by the term KI IN. Without this quality the painting, artistically considered and critically judged, must be pronounced a failure. Such picture may be perfect in proportion and design, correct in brush force and faultless in color scheme; it may have complied with the principles of IN YO, and TEN, CHI, JIN or heaven, earth and man; it may have scrupulously observed all the rules of lines, dots and ledges and yet if KI IN be wanting the painting has failed as a work of true art. What is this subtle something called KI IN?

In our varied experiences of life we all have met with noble men and women whose beautiful and

[82]

elevating characters have impressed us the moment we have been brought into relation with them. The same quality which thus affects us in persons is what the Japanese understand by KI IN in a painting. It is that indefinable something which in every great work suggests elevation of sentiment, nobility of soul. From the earliest times the great art writers of China and Japan have declared that this quality, this manifestation of the spirit, can neither be imparted nor acquired. It must be innate. It is, so to say, a divine seed implanted in the soul by the Creator, there to unfold, expand and blossom, testifying its hidden residence with greater or lesser charm according to the life spent, great principles adhered to and ideals realized. Such is what the Japanese understand by KI IN. It is, I think, akin to what the Romans meant by *divinus afflatus*—that divine and vital breath, that emanation of the soul, which vivifies and ennobles the work and renders it immortal. And it is a striking commentary upon artist life in Japan that many of the great artists of the Tosa and Kano schools, in the middle years of their active lives, retired from the world, shaved their heads, and, taking the titular rank of HOGEN, HOIN or HOKYO, became Buddhist priests and entered monasteries, there to pass their remaining days, dividing their time between meditation and inspired work that they might leave in dying not only spotless names but imperishable monuments raised to the honor and glory of Japanese art.

[83]

CHAPTER SIX

SUBJECTS
FOR JAPANESE PAINTING
(GWA DAI)

Painting
SubjectsA JAPANESE artist will never of his own accord paint a flower out of season or a spring landscape in autumn; the fitness of things insensibly influences him. From ancient times certain principles have determined his choice of subjects, according either to the period of the year or to the festivals, ceremonies, entertainments or other events he may be required to commemorate. All such subjects are called GWA DAI. As one without some knowledge of these cannot appreciate much that is interesting about art customs in Japan, a brief reference to them will be made, beginning with those subjects suitable to the different months of the year:

January—For New Year's day (SHO GWATSU

For January GWAN JITSU) favorite subjects are "the sun rising above the ocean," called *hi no de ni nami* (Plate LIV, No. 1); "Mount Horai" (2), "the sun with storks and tortoises" (3, 4, 5); or "Fukurokuju,"

[84]

a god of good luck. Many meanings are associated with these subjects. The sun never changes and the For January ocean is ever changing, hence IN YO is symbolized. The sun, the ocean and the circumambient air symbolize TEN CHI JIN or the universe. Horai (SAN) is a symbol for Japan. It is the lofty mountain on a fabled island in the distant sea, referred to in early Chinese writings, inhabited by sages (SEN NIN), and containing the pine, bamboo and plum (known in art as SHO, CHIKU, BAI), the pine standing for longevity, the bamboo for rectitude and the plum blossom for fragrance and grace. The stork and the tortoise, whose back is covered with seaweed, both typify long life, the ancient saying being that the stork lives for one thousand and the tortoise for ten thousand years (*tsuru wa* SEN NEN, *kame wa* MAN NEN). Fukurokuju is one of the seven gods of good luck, whose name means happiness, wealth and long life. On New Year's day are suspended on either side of his picture bamboo and plum subjects (Plate LV, 1, 2, 3). This jovial god's name is sometimes happily interpreted by a triple *kakemono* (SAN BUKU TSUI): The middle one is the sun and waves, for long life (JU); on the right, rice grains, for wealth (ROKU), and on the left the flower of the cotton plant, for happiness (FUKU), because its corolla is golden and its fruit silvery, the gold and silver suggesting felicity (Plate LVI, 1, 2, 3). This makes a charming combination.

An excursion into the fields of Chinese philology in connection with the name of this god of good luck would unfold some wonderful word picturing.

[85]

For January Traced to their hieroglyphical beginnings, FUKU signifies blessings from heaven; ROKU, rank, commemorated in carving, and JU, agricultural pursuits, associated with white hair.

An especially appropriate picture for this season of great festivity is called "the pine at the gate" (*kado matsu*). It commemorates the custom on the first day of the year of planting pine trees at the entrance to Japanese public buildings and private residences. From the rope (*shimenawa*) (Plate LV, 4) are suspended strips of white paper (*gohei*) typifying purity of the soul; these hang in groups of three, five and seven, the odd or lucky number series associated with the positive or male principle (YO) of IN YO. Another appropriate subject for this early season of the year is rice cakes (*mochi*) in the shapes of the sun and full moon (Plate LV, 5). In the picture the fruit called *dai dai* is placed on the top of the rice cakes, the word DAI meaning ages, hence associated with longevity. At the base of the stand is a prawn (*ebi*). This equally suggests old age because the prawn is bent in two. The leaf of the *yuzuri* is introduced because it is an auspicious word and means succession. The picture of a battledoor and shuttlecock (*hagoita*) is also appropriate for New Year as it commemorates the ancient practice of the Japanese indulging in that pastime on that day (Plate LVI, 4).

During January a very popular picture for the alcove (*tokonoma*) is the treasureship, called *takarabune* (Plate LVI, 5). The vessel as it sails into port is heavily laden with all of the various tools

[86]

and utensils typifying great wealth to be found in
the capacious bag of Dai Koku, a Japanese god of For January
good luck. These are a ball, a hammer, weights,
cloves, silver bronze, and the god's raincoat and
hat. On the evening of the second of January if the
painting of a treasureship be put under the pillow
and one dreams of either Fujisan, a falcon or an
eggplant, the year long he will be fortunate. It
will be observed that on the sail of the treasure
boat is inscribed the Chinese character for TAKARA,
meaning treasure. On the seventh day of January
occurs the first of the five holidays, called *go sekku*,
and vegetable subjects are painted. These are
called the seven grasses (*hotoke za* or *nana kusa*)
and consist of parsley, shepherd's purse, chickweed,
saint's seat, wild turnip and radish. They are sus-
ceptible of most artistic treatment and ingenious,
original designs are often evolved (Plate LVII, 6).

February—The cock and the hen, with the bud-
ding plum branch, are now appropriate. The sub- For February
ject is known as the "plum and chickens" (*ume ni
tori*) (Plate LVII, 1). The chicken figures in the
earliest history of Japan. When the cock crows
the Japanese hear the words KOKKA KOO, which,
phonetically rendered into Chinese characters, read
"happiness to our entire land." The Chinese hear
differently. To them the cock crows TOTEN KO,
meaning "the eastern heavens are reddening," so
to them the cock heralds the early morn. Famous
paintings of chickens have come from the brushes
of Okyo, Tessan (Plate III), and others of the Maru-
yama school. During February, the month of the

plum, the appropriate paintings are of that flower

For February and the Japanese warbler (*ume ni uguisu*) (Plate LVII, 2). This singing bird announces the spring with its melodious notes (HOHO KEKYO), which, rendered by the Buddhist into Chinese characters, give the name of the principal book of the eighteen volumes of Shaka, entitled, "the marvelous law of the lotus." Another picture suitable to February is known as "the last of the snow" (*zan setsu*) (Plate LVII, 3).

For March March—This month is associated with the peach blossom, and *kakemono* of gardens containing peach trees, called *momo no* EN (Plate LVII, 4), are in favor. Toba Saku is related to have lived eight thousand years subsisting upon the fruit of the peach; hence, the peach blossom is a symbol for longevity, and *sake* made from the fruit is drunk throughout Japan in March. One of the most famous prose writings in Chinese literature is RANTEI KIOKA SUI. It commemorates a pastime of the learned, called "the *sake* cup." A favorite way of interpreting this subject is to paint a garden of blossoming peach trees and spreading banana palms bordering a flowing stream, with a nobleman attaching to a peach branch a narrow paper (TANJAKU) upon which he has written a poem. Another famous Chinese prose composition, "the peach and apricot garden festival," written by Ri Tai Haku at the age of fourteen years, is interpreted by depicting Toba Saku in a garden seated before a table, with three Chinese beauties attendant upon him, with celebrated scholars and sages

[88]

circulating midst the flowers and blossoms. Five principal festivals of the year, known as *go sekku,* For March occur respectively on the seventh day of January, the third day of March, the fifth day of May, the seventh day of July and the ninth day of September—all being on the odd days of the odd months (the YO of IN YO). On the third day of the third month is the *hina matsuri* festival for young girls, and the appropriate painting for the occasion is called *kami bina,* meaning paper dolls (Plate LVII, 5). The greatest Japanese artists of the past have vied to make their treatment of this subject superb. When a female child is born a *kami bina* painting is presented to the family to contribute to the festivities. The month of March is the month of the cherry blossom (*sakura bana*), and the picture on Plate LVIII, 1, illustrates one method of painting cherry trees ornamenting the mountainside of a canyon, through which flows a river. During March picnic parties go upon the beach at low tide to gather shell-fish. The subject illustrated on Plate LVIII, 2, called ebb-tide (*shio hi*), is appropriate. The picture of the maiden Saohime (Plate LVIII, 3) is also painted in March.

April—The wistaria flower (*fuji*) is associated For April with the fourth month and all April landscapes represent the trees covered with much foliage. A small bird called *sudachi dori,* hatched in this month, is often painted on the wistaria branch (Plate LVIII, 4). The picture typifies parental affection, on account of the known solicitude of the mother bird for its young.

May—There are many subjects appropriate for
For May May. The iris (*shobu*) (Plate LVIII, 5) now makes
its appearance. Its long-bladed leaves are sword
shaped, therefore the plant symbolizes the warrior
spirit (*bushi*). The iris is often planted upon the
roof of a house to indicate that there are male
children in the family. The cuckoo and the moon
subject (*tsuki ni hototogisu*) (Plate LVIII, 6) is special
to this month. The fifth of May is the boys' festi-
val, and the carp (*koi*) (Plate LIX, 1) is the favorite
subject for painting. May is the rainy month in
Japan. It is related that a carp during this month
ascended to the top of the waterfall RYU MON in
China and became a dragon. The carp thus typifies
the triumph of perseverance—the conquering of
obstacles—and symbolizes the military spirit.
When this fish is caught and about to be cut up
alive for *sasshimi*, a Japanese delicacy, once the
carver has passed the flat side of the knife blade
over the body of the fish the *koi* becomes motion-
less, and with heroic fortitude submits to being
sliced to the backbone. Served in a dish, a few
drops of *soy* being placed in its eye it leaps upward
in a last struggle, to fall apart in many pieces.
When a male child is born a proper present to the
family is a carp *kakemono*. The fifth day of the
fifth month is the anniversary of the great victory
of the Japanese over Kublai Khan, who, with an
enormous fleet of Chinese vessels, attempted to
invade Japan in the thirteenth century.

For June June—In this warm month the GWA DAI or pic-
ture subject is waterfalls (Plate LIX, 2), although it is

[90]

quite allowable on account of the heat of summer
to suggest cool feelings by painting snow scenes _{For June}
with crows (SETCHU *ni karasu*) for a color contrast
(Plate LIX, 3). All pictures painted during the
month of June should suggest shady, refreshing
sensations. A charming and favorite subject is
water flowing through an open bamboo pipe and
falling amid luxuriant vegetation into a pool below,
where a little bird is bathing. This picture is
technically known as *kakehi* (Plate LIX, 4).

July—During this month appropriate among _{For July}
flower subjects is that of the seven grasses of au-
tumn (*aki no nana kusa*) (Plate LIX, 6), consisting of
the bush clover, the wild pink, the morning glory,
et cetera. This is most difficult to paint on account
of the extreme delicacy requisite in the handling
of the brush, but a skilful artist can produce most
interesting effects. All sorts of wonderfully shaped
insects as well as birds of brilliant plumage are
permitted in the picture. The seventh day of July
is known as the festival of the stars, and *Kengyu,*
the swain, and *Orihime*, the maiden, are painted.
July is a month devoted to Buddhist ceremonies.
Saints, sages, the five hundred rakkan disciples of
Shaka and the sixteen rakkans are painted. There
are two other subjects appropriate, known as *Tan-
abata* (Plate LIX, 5) and *Nazunauchi*(Plate LXIV,4).

August—The first grain of the year is now _{For August}
offered to the gods. A charming way of commem-
orating this is by the painting called stacked rice
and sparrows (*inamura ni suzume*) (Plate LX, 1).
The rabbit and the moon, called *tsuki ni usagi*

[91]

(Plate LX, 2), because the rabbit is seen in the moon
For August making rice cakes, and the picture known as *meg-getsu* (Plate LX, 3) also commemorate the offering
of the products of the soil to the moon divinity.
As mist abounds during August, landscapes half
concealed in mist are painted. The Kano artist,
Tanyu, leaned much to such scenes, which suggest
the tranquility of eventide. Such subjects are known
as mist showers (*ugiri*) (Plate LX, 4). The Japanese
have their woman in the moon, named Joga. This
lovely creature having procured and drunk of the
ambrosia of hermits (*sennin*) is said to have entered
that planet. The picture is an engaging one (Plate
LX, 6), the upper portion of Joga's body being in
the moon's disc and the lower portion in fleecy
clouds.

For September September—The ninth day of the ninth month is
the festival of the chrysanthemum (KIKU NO SEKKU),
when *sake* made from the chrysanthemum is drunk.
Kiku Jido, a court youth, having inadvertently
touched with his foot the pillow of the emperor, was
banished to a distant isle where, it is said, he was
nourished by the dew of the chrysanthemum which
abounded there. Becoming a hermit, he lived one
thousand years. Seasonal pictures for this month
commemorate this event, or reproduce the yel-
low and white chrysanthemum. (Plate LXI, 1).
Appropriate for September are water grasses and
the dragon-fly (*mizukusa ni tombo*) (Plate LX, 5).
Tatsuta hime (Plate LXI, 2) is also painted. She is
the autumn divinity, associated with the brilliant,
warm and resplendent colors of the autumn season,

[92]

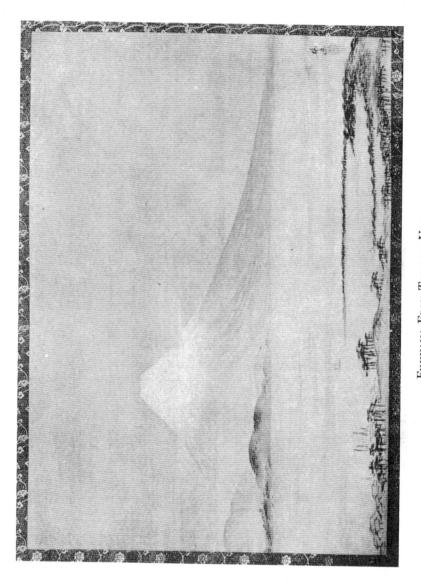

FUJIYAMA FROM TAGO NO URA
BY YAMAMOTO BAIETSU
Plate VIII

and is always represented in gorgeous hues. Pictures of the deer and the early maples (*hatsu momiji* For September *ni shika*) (Plate LXI, 3) are now appropriate. A favorite autumn picture is called *Kinuta uchi*, or the beating, on a block, of homespun cotton to give it lustre. A poor peasant woman and her child are both occupied at the task under the rays of the full moon (Plate LXIV, 4). The sound of the blows on the block is said to suggest sad feelings. It is a law for painting such moonlight scenes that no red color be introduced, as red does not show in the moonlight (GEKKA *no* KO SHOKU *nashi*).

October—In this month geese coming from the For October cold regions and crossing at night the face of the moon are a favorite subject, known as *tsuki ni* GAN (Plate LXI, 4). Other subjects are "autumn fruits" (*aki no mi*) (Plate LXI, 5), chestnuts, persimmons, grapes and mushrooms; monkeys and persimmons (*saru ni kaki*) (Plate LXI, 6); squirrel and grapes (RISU *ni* BUDO) (Plate LXII, 1); and the evergreen pine (*kayenu matsu*), suggesting constancy (LXII, 2)

November—A month sacred to Evesco, one of For November the jovial gods of good luck (Plate LXII, 3). He was the first trader, his stock being the TAI fish. He is the favorite god of the merchants who, during this month, celebrate his festival. Evesama is usually represented returning from fishing with a TAI under his arm. The Kano artists particularly favored this subject. Another charming picture, known as "the last of the chrysanthemums" (ZAN KIKU) (Plate LXII, 4), suggests the approaching close of the year. The classic way to represent this sub-

[93]

ject is with small, yellow chrysanthemums clinging to a straggling bamboo fence, with a few of their leaves which have begun to turn crimson. Another November picture is "the first snow" (*hatsu yuki*) (Plate LXII, 5). Two puppies are frollicking in the snow, which is falling for the first time. It is said that no animal rejoices like the dog when it sees the first snowfall of winter. Snow, says a proverb, is the dog's grandmother (*yuki wa inu no obasan*). Okyo and Hokusai frequently painted this subject. *Hatsu yuki* is sometimes represented by a little snow upon the pine tree or the bamboo in a landscape. This produces a very lonely (*samushii*) scene. The Kyoto artists are extremely fond of painting in the month of November the subject of a peasant girl descending from the mountain village of Ohara carrying upon her head a bundle of firewood twigs, into which she has coquettishly inserted a branch of red maple leaves. This picture is called *Oharame* (Plate LXII, 6). Landscapes representing fitful rain showers are appropriate for November and are called *shigure*. This is the month for the *oshi dori* (Plate LXIII, 1). These mandarin ducks, male and female, on account of the contrast in their shape and plumage, make a very striking and favorite picture. Their devotion to each other is so great that they die if separated. Hence, such paintings not only symbolize conjugal fidelity but are also appropriate as wedding presents. There are two other kinds of birds painted in November: The beach birds, known as *chi dori* (Plate LXIII 2), and the wild duck flying over the marsh grasses (*kamo ni ashi*) (Plate

[94]

LXIII, 3). Okyo and the artists of his school excel in their vivid treatment of these last three subjects.

December—The cold weather chrysanthemum For December (KAN KIKU), the narcissus or hermit of the stream (SUI SEN), and the snow shelter of rice straw (*yuki kakoi*) (Plate LXIII, 4) are three favorites for December. In this latter lovely subject the white chrysanthemums are huddling below the protecting snow shelter of rice straw, one or two of the flowers peeping out, their leaves being reddish on the rim and light green within. The narcissus is much painted during December. There are many ways and laws for painting this flower. Another winter subject is called *joji* BAI, consisting of the plum tree with snow on the branches and small birds perched thereon. Kyoto artists much favor it. December landscapes are all snow scenes (*yuki no* SAN SUI) (Plate LXIII, 5) and countless are the ways in which they are treated. Another subject is *nukume dori*— a falcon perched upon a tree covered with snow, holding in its claws a little bird (Plate LXIV, 3). The falcon does not tear its victim to pieces but simply uses it to warm its own feet; this accomplished, it lets its prisoner escape and during twenty-four hours refrains from flying in the direction the little bird has fled. *Noblesse oblige.*

The snow man or snow *daruma* (*yuki daruma*) (Plate LXIII, 6) is painted this month by artists of all the schools.

The four seasons (SHI KI) form a series susceptible The Four Seasons—How Interpreted of the most varied and engaging treatment and presentation. The seasons are sometimes symbol-

[95]

ized by flowers, occasionally by birds, again by the products of the earth, and often by landscapes. Sometimes human figures are used for the purpose. In spring (*haru*) a young daughter (*musume*) may be represented looking at the cherry blossoms (Plate LXV, 1); in summer (*natsu*) she will be crossing a bridge or enjoying the cool of the riverside (Plate LXV, 2); in autumn (*aki*) she is seen in the fields, probably gathering mushrooms (Plate LXV, 3), and in winter (*fuyu*) she will be seated indoors playing a musical instrument (Plate LXV, 4). While the *kakemono* is always to be changed in the *tokonoma* or alcove according to the seasons, ceremonies or festivals, there are certain pictures appropriate to any season, *e. g.*, rocks and waves (*iwa ni nami*); pine and bamboo (*matsu take*); or the Okyo double subject called *shikuzu ni fuku tsui* (pendant paintings): The end of spring, a crow and the plum tree (Plate LXIV, 1); the end of autumn, the bird *hyo dori* and the persimmon tree (Plate LXIV, 2). The reason is that all such subjects are in harmony with conditions the year round.

The Four Seasons—How Interpreted

Other Subjects—At All Times Appropriate

Historical subjects (REKISHI GWA DAI) suitable for Japanese painting are extremely numerous and are divided into categories corresponding to the following periods: The Nara, the Heian or Kyoto, the Kamakura Yoritomo shogunate, the Higashiyama shogunate, the Yoshimasa shogunate, the Momoyama or Taiko Hideyoshi, and the Tokugawa Iyeyasu shogunate brought down to the present Meiji period. These with their numerous subdivisions supply an infinite number of subjects for

Historical Subjects

[96]

pictorial treatment. Special favorites are "Benkei and Yoshitsune at the Go Jo bridge," or "passing through the Hakone barrier," and "Kusanoki Masashige at Minatogawa."

When Shaka was born he stood erect, with one hand pointing upward and the other downward and exclaimed: "Behold, between heaven and earth I am the most precious creation." His birthday is the subject of the picture (Plate LXVI, 3) called KAN BUTSU YE. It represents the Buddha as a bronze statue erect in a tub of sweet liquid. This the faithful worshippers pour over his head and subsequently drink for good luck. Shaka's death is commemorated in the picture called NEHAN, nirvana. The lord, Buddha, is stretched upon a bier tranquilly dying, an angelic smile lighting his countenance, while around are gathered his disciples, Rakkan and Bosatsu, and the different animals of creation, all weeping. A rat having gone to call Mayabunin, mother of Buddha, has been pounced upon by a cat and torn to pieces. For this reason in paintings of this moving scene of Shaka's death no cat is to be found among the mourning animals. The artist Cho Densu, however, in his great painting of NEHAN (still preserved in the Temple To Fuku Ji at Kyoto) introduces the portrait of a cat. It is related that, while Cho Densu was painting, the cat came daily to his side and continually mewing and expressing its grief, would not leave him. Finally Cho Densu, out of pity, painted the cat into the picture and thereupon the animal out of joy fell over dead.

Buddhist Subjects

[97]

The lotus (*hasu*) symbolizes the heart of a saint

Buddhist Subjects (*hotoke*). It rises untarnished out of the mud of the pond, nor can it be stained by any impurity, the leaves always shedding whatever may fall upon them. It is painted usually as a religious subject.

The principal *matsuri* or Shinto festivals occur **Shinto Subjects** at different seasons of the year in different parts of the empire. The summer months, however, claim most of them. The *Kamo no aoi matsuri* takes place at Kyoto and consists of a procession, a NO dance and a horse race. The picture appropriate for this festival is "the *Kamo* race course" (*Kamo no kei ba*). The *matsuri* at Nikko is a great procession, with three *mikoshi* or shrines carried on the shoulders of multitudes of men. There are three Nikko *matsuri* connected with the Tokugawa shogunate.

Inari, being the god of agriculture (*ine*, rice), the picture of a fox (Plate LXVI, 4), that god's messenger, is appropriate. Another festival, the GYON *matsuri*, of Kyoto, is celebrated with a great procession in which enter all sorts of amusing floats and every kind of amusing practice. These are variously reproduced in commemorative paintings.

I will only refer in passing to the many subjects **Poems and Romances** supplied by the beautiful poetry (HOKKU and *uta*) and celebrated romances (*monogatari*) of Japan. Enough has been said to show that the Japanese artist has an unlimited range of classic subjects from which to select.

Miscellaneous Subjects Other subjects unassociated with any special time of the year represent, *e.g.*, various utensils of the tea

[98]

ceremony (*cha no yu*) (Plate LXVI, 1) when *macha*, a thickened tea, is used. The tea ceremony (Plate II) is performed in a small room fitted with four and a half mats. Were the mats only four (SHI) in number they would suggest death (*shi*). Furthermore, an even number being considered negative (IN) is not favored. Mats are three by six feet in size and must always be so laid as not to form crosses, which are unlucky. In the alcove of this room no *kakemono* is permitted but one in the pure Japanese style. The subject of the painting will depend upon the season, while all red colors are proscribed and *sumi* pictures of the Kano school are most appropriate. The treatment must be simple (TAN PAKU); for instance, a single flower spray, a branch of the plum, a hermit, or a solitary mountain peak. In the ceremony of SEN CHA (Plate LXVI, 2), which is the Chinese way of making tea, these strict rules of *cha no yu* are relaxed.

Miscellaneous Subjects

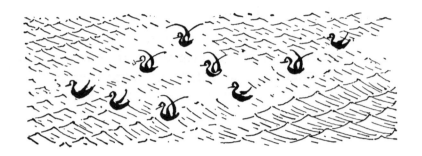

CHAPTER SEVEN

SIGNATURES AND SEALS
(RAKKWAN AND IN)

Chinese Manner

THERE are many books upon the subject of signing and authenticating a painting. Two well-known works are "GWA JO YO RYAKU" and "DAI GA SHI SAN." In China literary men often add descriptive matter to their paintings, writing prominently thereon: "In a dream last night I witnessed the scene I here attempt to reproduce," or "On a boating excursion we saw this pine tree shading the banks of the river." Such additions to the picture enable the artist to exhibit his skill as an expert writer and are considered to heighten the general effect. Often original poetry takes the place of prose. The year, month and day will be added, followed by the signature of the writer, with some self-depreciatory term, such as "fisherman of the North Sea," "mountain wood-chopper" or "hermit dwelling amid the clouds and rocks." Such signature, with one or more seals scattered over the face of the work, is in art called RAKKWAN, signifying "completed."

[100]

In Japan a somewhat different way of signing prevails. The artist's signature with his seal under it is appended to the painting, not in a conspicuous but in the least prominent part of it.

Painters of the Tosa, Fujiwara, Sumiyoshi and Kasuga schools in signing their work first wrote above their signatures their office and rank, *e. g.*, Unemi no Kami or Shikibu Gondai no Kami in the square or round Chinese characters.

The Kano artists signed their names in round characters (GYO SHO) and did not add their secular rank or office but wrote before their signatures their Buddhist titles; thus, HOGAN Motonobu, HO KYO Naganobu, HOIN Tsunenobu. In the Maruyama period all titles and rank were omitted and simply the name (*namae*) or the *nom de plume* (GO) was written,—thus, Okyo, Goshun, Tessan, Bun Cho— strict attention being paid, however, to executing the Chinese characters for such signatures in both an artistic and strikingly attractive way, whether written in one or another of the three usual forms technically called SHIN, SO, GYO.

The date, NEN GO, preceding the signature upon a painting is often indicated by the use of one of the twelve horary characters (JU NI SHI) along with one of the ten calendar signs (JU KAN). These, in orderly arrangement, comprehend a cycle of sixty years; in other words, they are never united the same way or coincide but once during that period. No artist under sixty should, in signing his work, allude to his age, much less state his years. For him to be able to write seventy-seven before his name is

[101]

most auspicious—one way of writing *kotobuki*, the luckiest word in Japanese, being to employ two sevens which, thus compounded, is said to be the so SHO character for that word. Very young persons are permitted in signing their paintings or writings to add their exact ages up to thirteen.

Where Chinese literary artists add poems to their paintings as many as eight seals may be observed thereon. In Japanese paintings never more than two seals are used and these follow and authenticate the signature.

The correct distance at which a *kakemono* is to be viewed is the width of a mat (*tatami*) from the alcove where the picture is hung. It is bad form to look at it standing. Before critically examining the work a Japanese will scrutinize the artist's signature and seal. It is a cardinal rule in Japan that the signature be affixed so as not to interfere with the scheme of the picture or attract the eye. If the picture looks to the right the signature and seal should be placed on the left, and *vice versa;* if the principal interest is in the upper part of a picture these should be placed lower down, and *vice versa.* As every painting has its division into IN and YO, the RAKKWAN is placed in IN. Some artists partially cover their signatures with their seal impression. Lady artists add to their signatures the character JO, meaning woman. Veteran painters will sometimes write before their signatures the character for old man (*okina*).

The artist's seal is often a work of art and his family name (MYOJI) or his artist name (GO) is usu-

ally engraved thereon with the Chinese seal charac-
ters called TEN SHO. Where two seals are affixed
below the signature one may contain a classic aphor-
ism, like TAI BI FU GEN (the truly beautiful is inde-
scribable) or CHU YO (keep the middle path). Before
seals were used writings were authenticated by
scrolls called *kaki* HAN. Even now such scrolls are
used. The principles on which they are shaped are
derived from astrological lore (EKI). Seal engravers
deservedly enjoy renown for learning and skill. To
carve a seal is the recognized accomplishment ot
a gentleman, and the most famous living seal
engraver in Japan is an amateur. Seals are of jade,
rock crystal, precious woods, Formosa bamboo root,
gold, silver or ivory. The best hard stone for seals
comes from China and is known as the cock's comb
(KEI KETSU SEKI).

An artist during his career will collect numbers
of valuable seals for his own use. These at his
death may be given to favorite pupils or kept as
house treasures. Bairei left instructions to have
many of his seals destroyed.

The seal paste (NIKU) is made of Diana weed
(*mogusa*) dried for three years, or of a plant called
yomogi, or with soft, finely chopped rabbit hair
boiled in castor oil for one hundred hours with
white wax and then colored red, brown, blue or tea
color. The seal should be carefully wiped after
it is used, otherwise this paste hardens upon it.

Japanese paintings are seldom framed, as frames
take too much room. Frames are used chiefly for
Chinese writings, hung high in public places or

[103]

Frames about the dwelling, and are called GAKU, meaning "forehead," in allusion to raising the head to read what the frame contains. It is etiquette that such framed writings be signed with the real name rather than the *nom de plume*.

Two kinds of seals are affixed to the frame: One, on the right, at the beginning of the writing, and called YU IN, containing some precept or maxim; and one or two, on the left, after the signature, bearing the artist's name and any other appropriate designation. All writings in Chinese or Japanese read from right to left, and frequently are the sole ornament of a pair of screens.

For the guidance of experts who pass on the genuineness of Japanese paintings there is a well-known publication, "GWA KA RAKKWAN IN SHIN," by Kano Jushin, which contains reproductions in fac simile of the signatures and seals of all the celebrated artists of the remote and recent past.

A Parting Word In concluding this work, which I am conscious is but an imperfect survey of a vast and intricate subject, I would call attention to the fact that in both Europe and America there is a wonderful awakening to the dignity, simplicity and beauty of Japanese art. This is largely to be attributed to the careful and scholarly writings and publications of Messrs. Anderson, Binyon, Morrison and Strange in England, Fenollosa in the United States, De Goncourt, Gonse and Bing in France, Seidlitz in Germany, and Brinkley and Okakura in Japan; and all students of art must render to them the homage of their sincere admiration.

[104]

The object of all art, as Cicero has truly said, is to soften the manners, by training the heart and mind to right thoughts and worthy sentiments. To such end nothing will more surely contribute than a faithful study of the painting art of Japan, and the further we investigate and appreciate its principles the more we will multiply those hours which the sun-dial registers,—the serene and cheerful moments of existence.

A Parting Word

PLATES EXPLANATORY OF
THE FOREGOING TEXT ON THE LAWS
OF JAPANESE PAINTING

THE EIGHT WAYS OF PAINTING IN COLOR, CALLED THE LAWS OF COLORING

PLATE IX

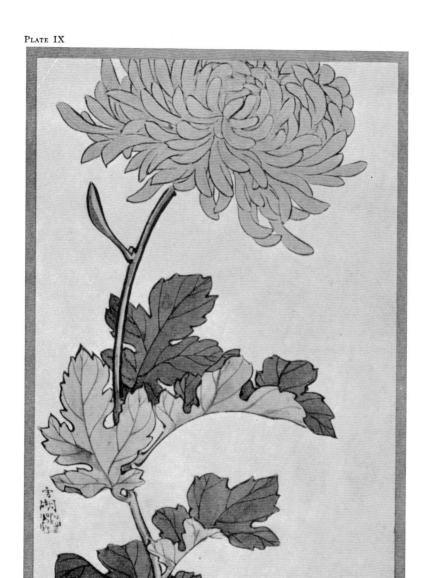

PLATE X

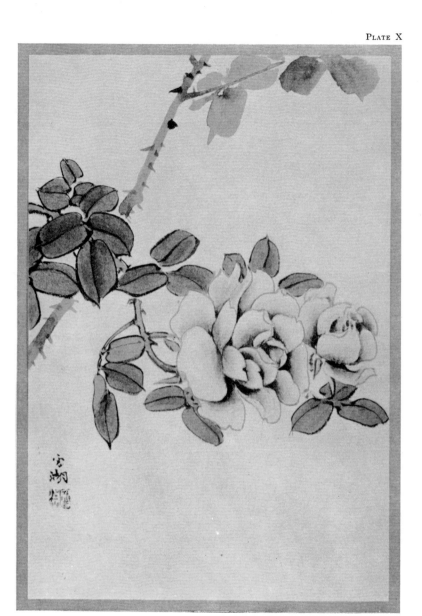

PLATE XI

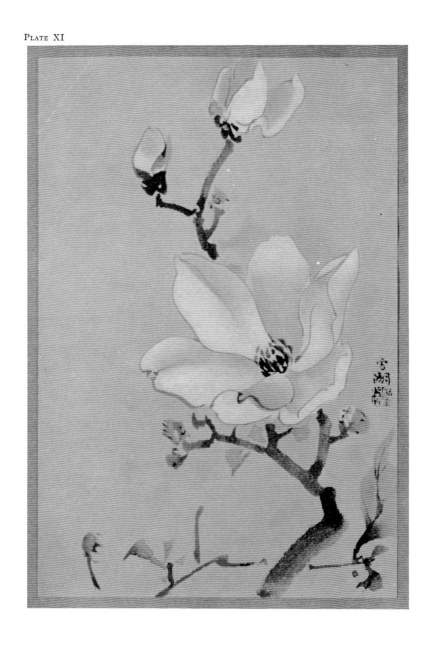

PLATE XII

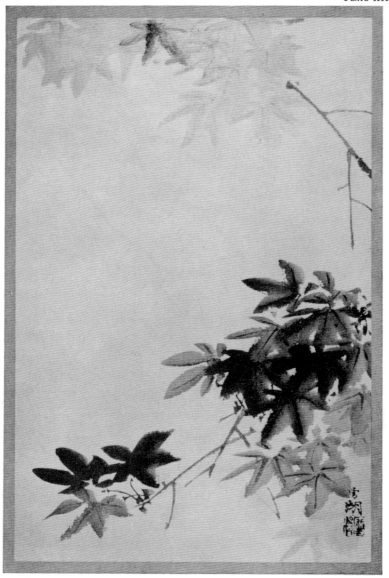

Plate XIII

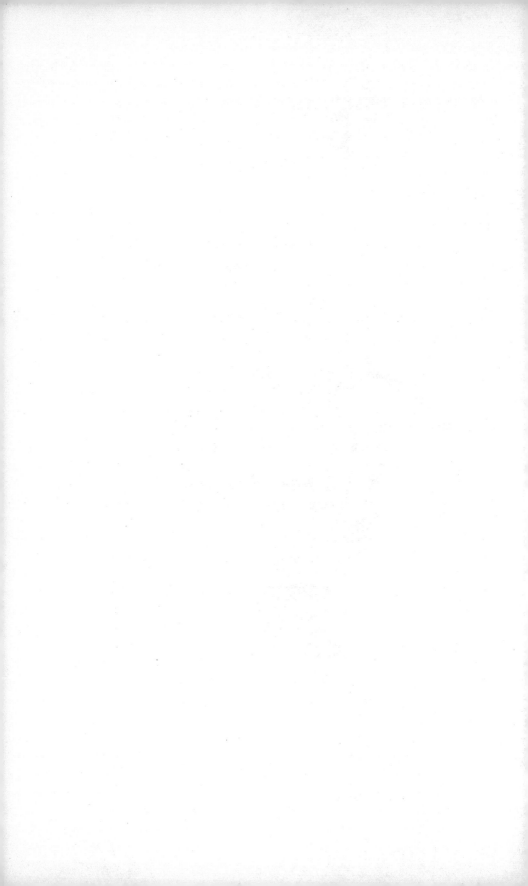

PLATE XIV

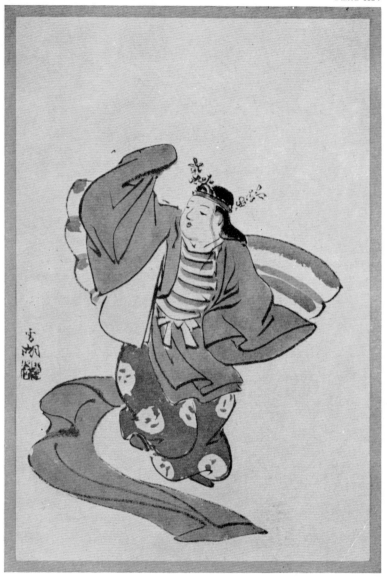

PLATE XV

PLATE XVI

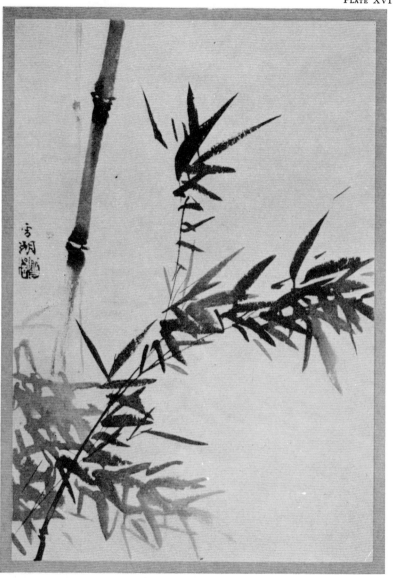

ILLUSTRATIONS OF PRINCIPLES FOR
PAINTING LANDSCAPES, BIRDS, PINE AND OTHER
TREES AND WINDING STREAMS

PLATE XVII

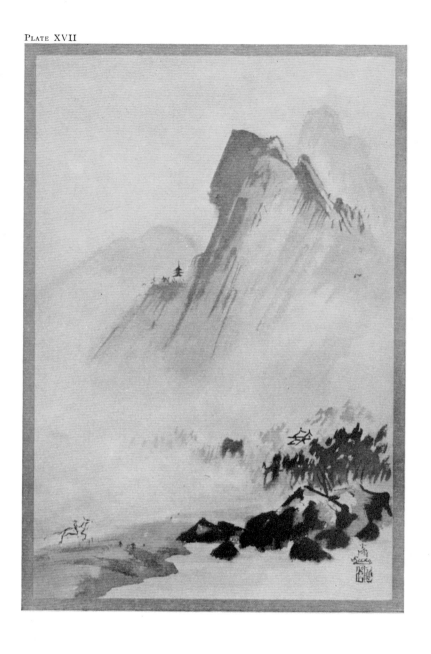

PLATE XVIII

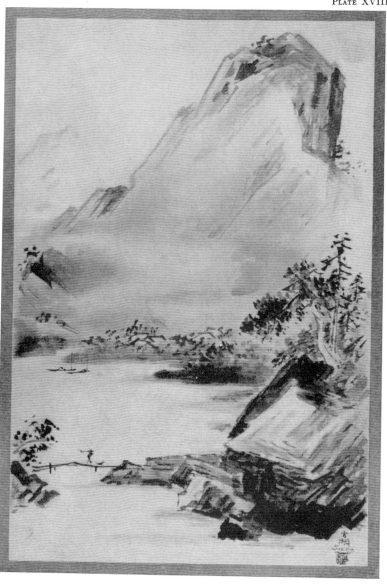

PLATE XIX

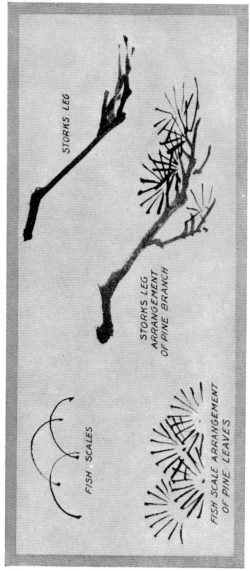

STORKS LEG

STORKS LEG
ARRANGEMENT
OF PINE BRANCH

FISH SCALES

FISH SCALE ARRANGEMENT
OF PINE LEAVES

PLATE XX

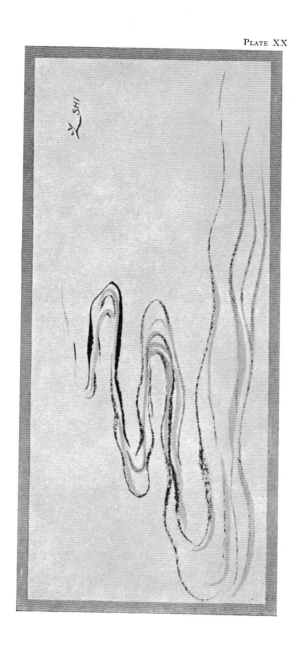

PLATE XXI

PLATE XXII

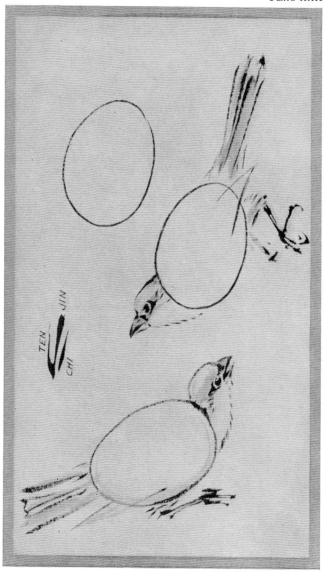

THE EIGHT LAWS OF LEDGES FOR PAINTING MOUNTAINS, ROCKS AND CLIFFS

Plate XXIII

A

B

PLATE XXIV

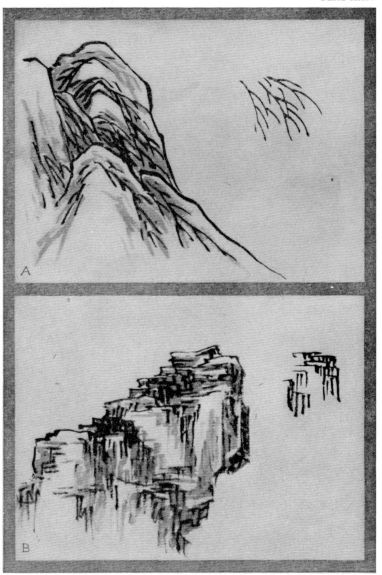

Plate XXV

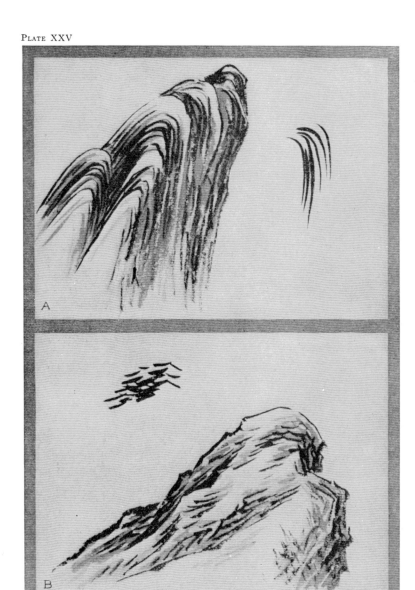

PLATE XXVI

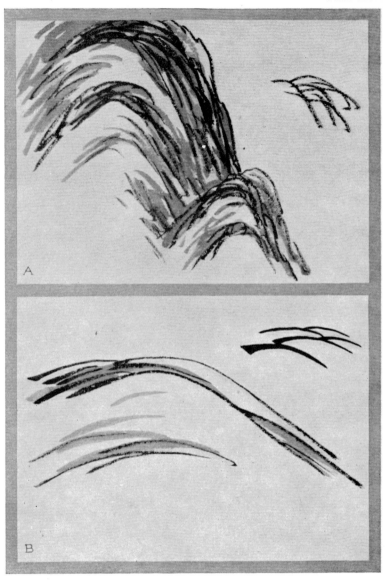

A

B

ILLUSTRATIONS OF OTHER LAWS FOR PAINTING
TREES AND ROCKS

PLATE XXVII

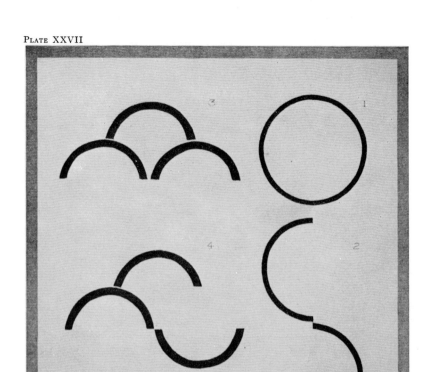

PLATE XXVIII

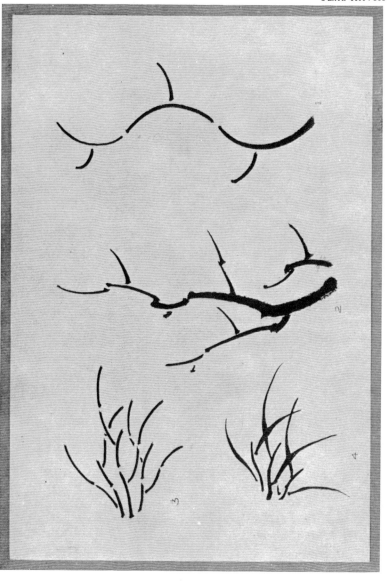

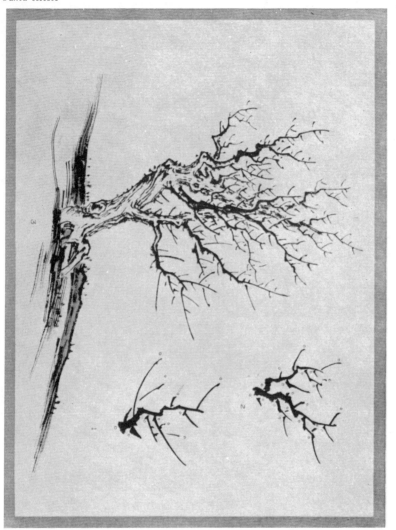

PLATE XXIX

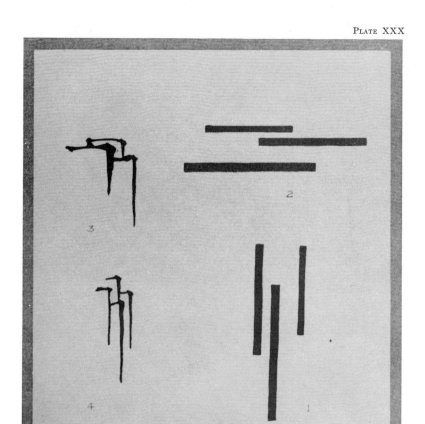

PLATE XXX

Plate XXXI

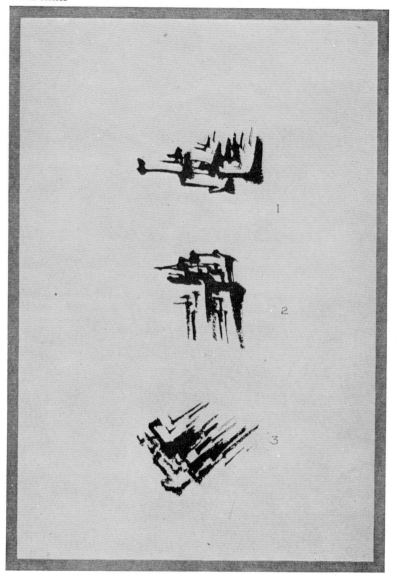

THE TWELVE LAWS
OF DOTS FOR PAINTING NEAR OR DISTANT
TREES AND SHRUBS

PLATE XXXII

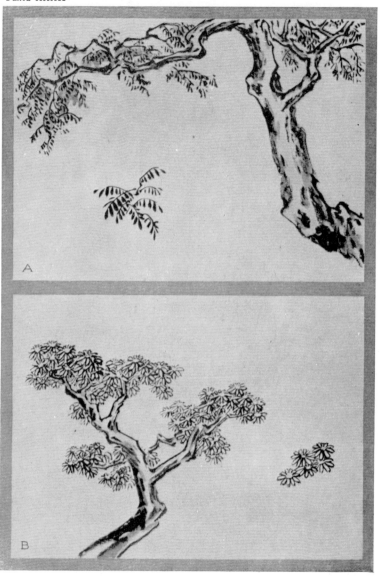

PLATE XXXIII

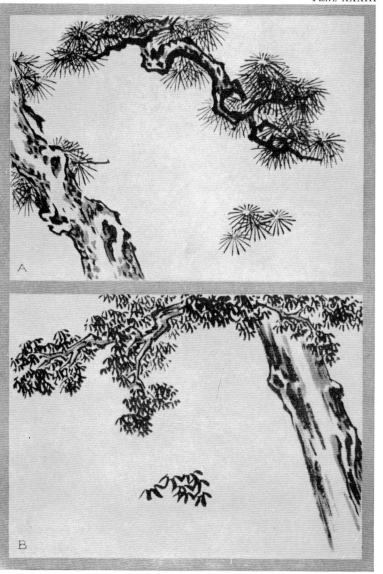

PLATE XXXIV

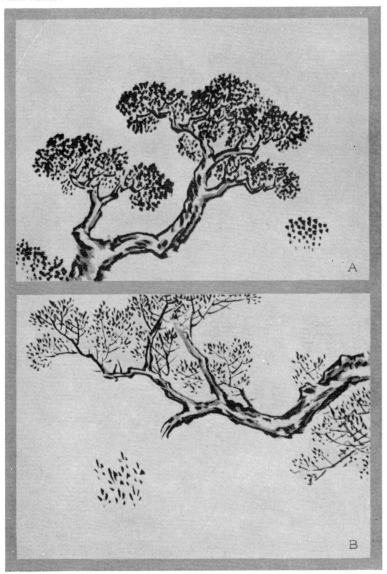

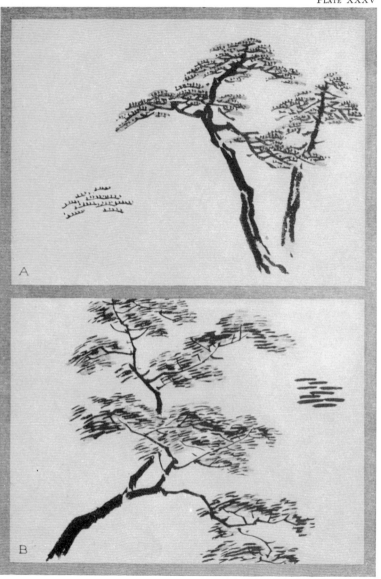

PLATE XXXV

PLATE XXXVI

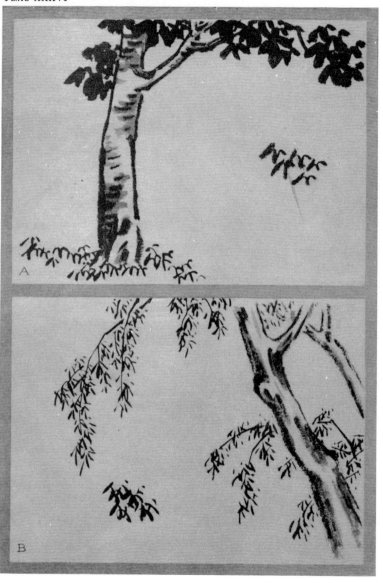

PLATE XXXVII

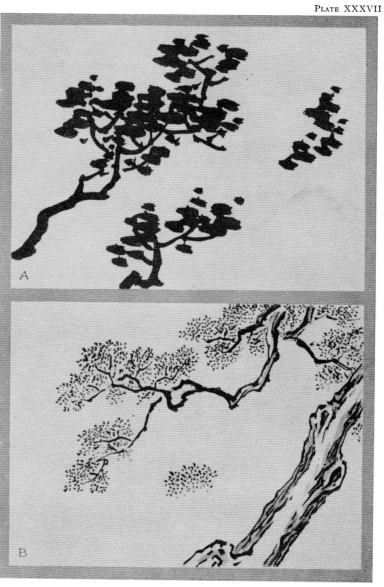

ILLUSTRATIONS OF THE LAWS FOR PAINTING
WAVES AND MOVING WATERS

PLATE XXXVIII

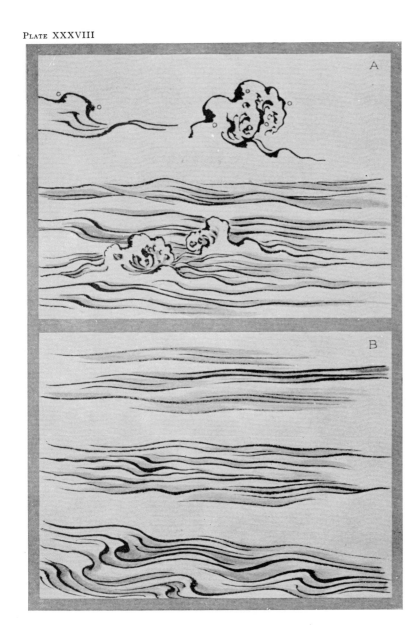

Plate XXXIX

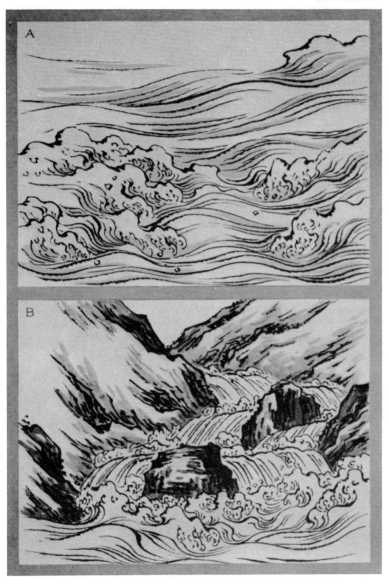

Plate XL

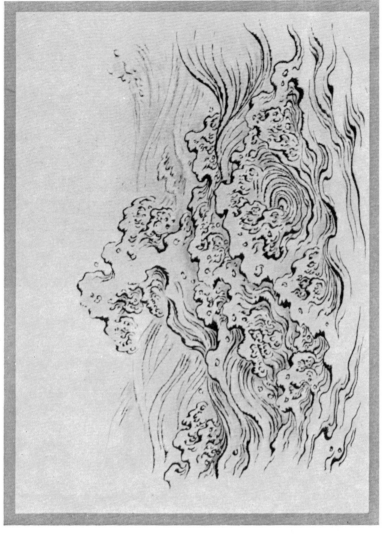

THE EIGHTEEN LAWS FOR PAINTING THE LINES OF THE GARMENT

PLATE XLI

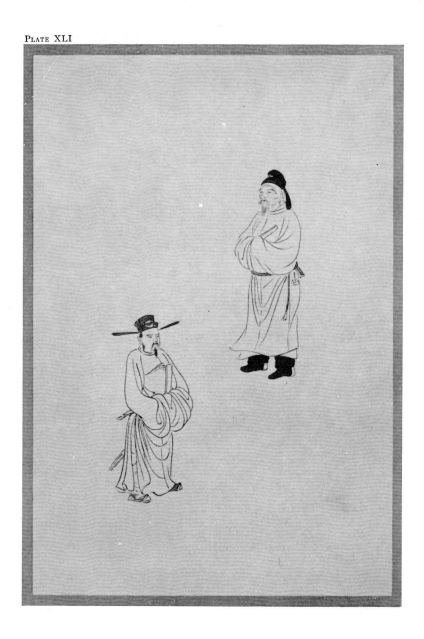

PLATE XLII

PLATE XLIII

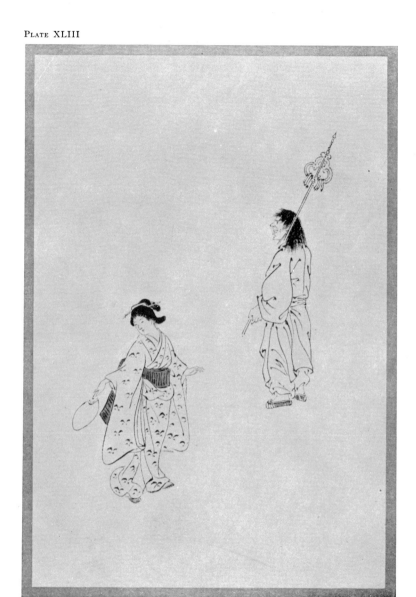

PLATE XLIV

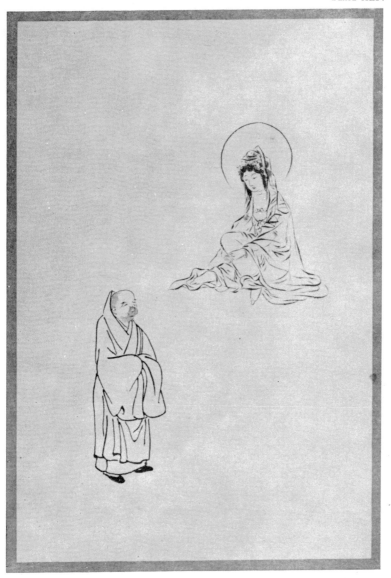

Plate XLV

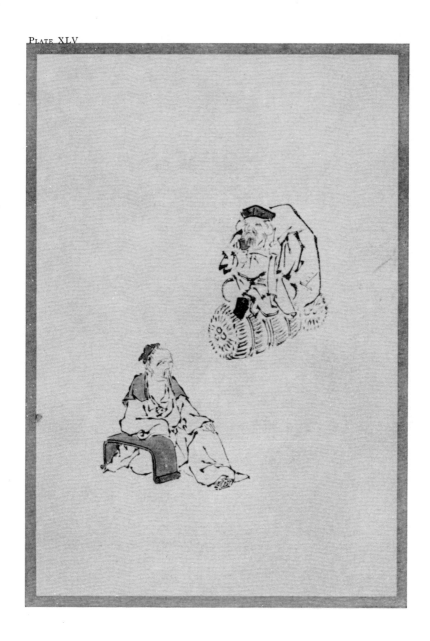

PLATE XLVI

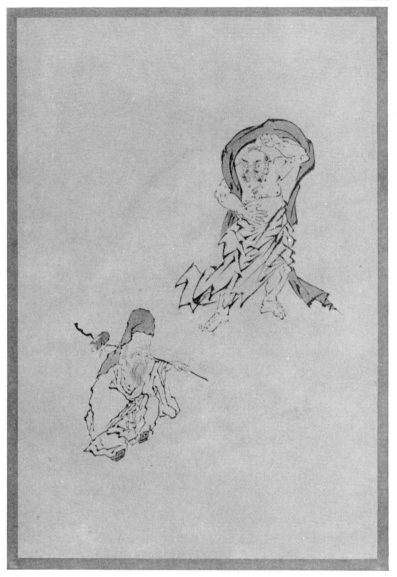

PLATE XLVII

PLATE XLVIII

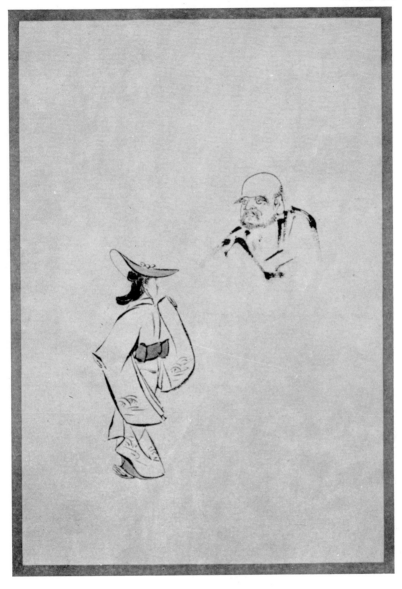

PLATE XLIX

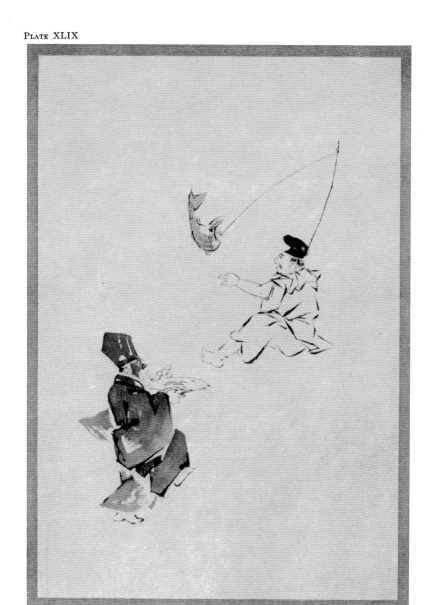

ILLUSTRATIONS OF THE VARIOUS
LAWS FOR PAINTING THE ORCHID, BAMBOO, PLUM
AND CHRYSANTHEMUM, CALLED THE
FOUR PARAGONS

Plate L

PLATE LI

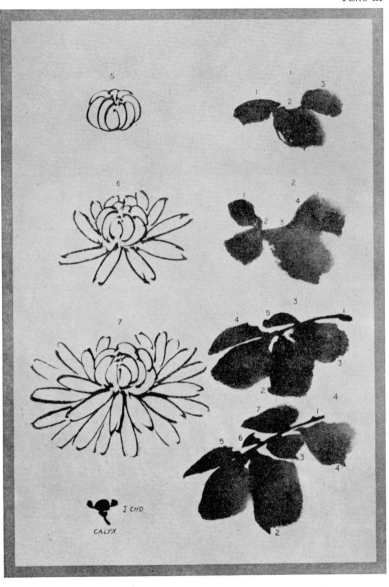

Plate LII

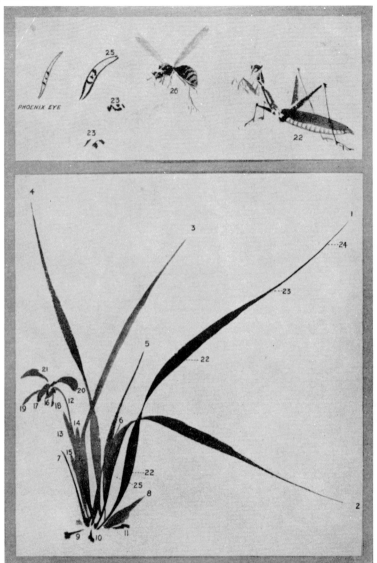

PLATE LIII

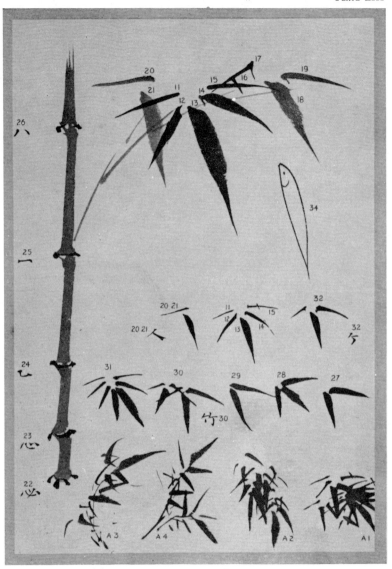

ILLUSTRATIONS OF VARIOUS SUBJECTS PECULIAR
TO JAPANESE PAINTING

PLATE LIV

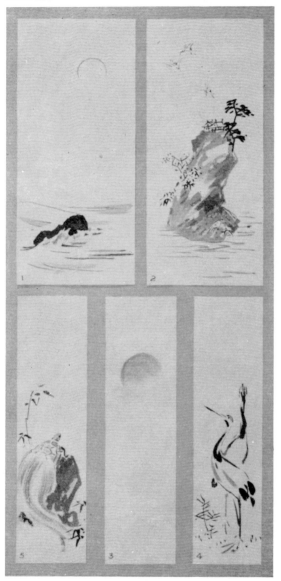

PLATE LV

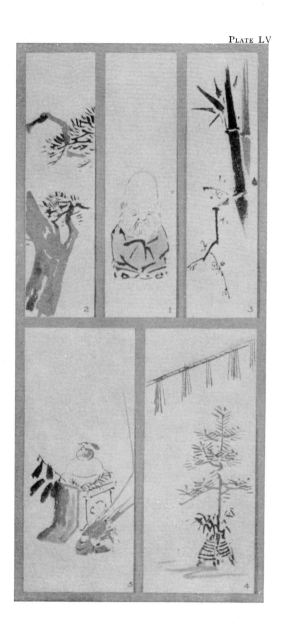

PLATE LVI

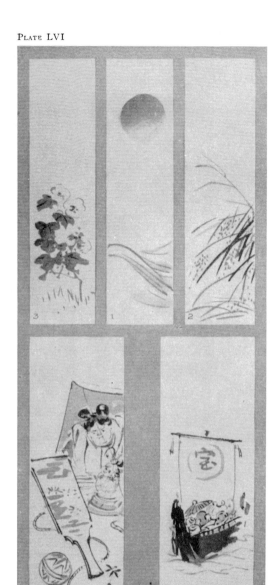

PLATE LVII

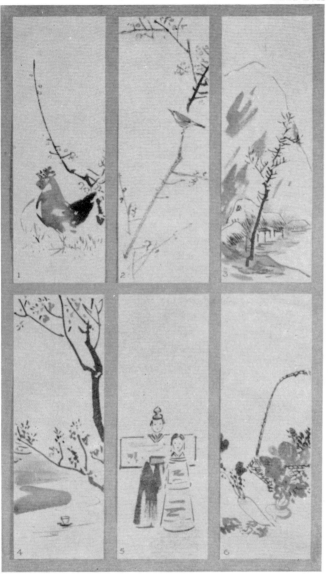

Plate LVIII

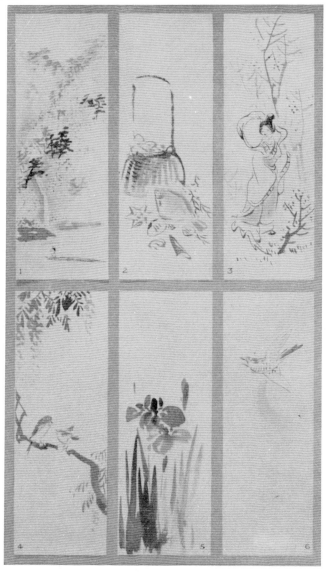

PLATE LIX

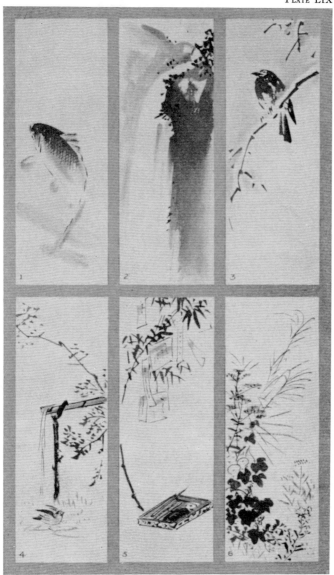

PLATE LX

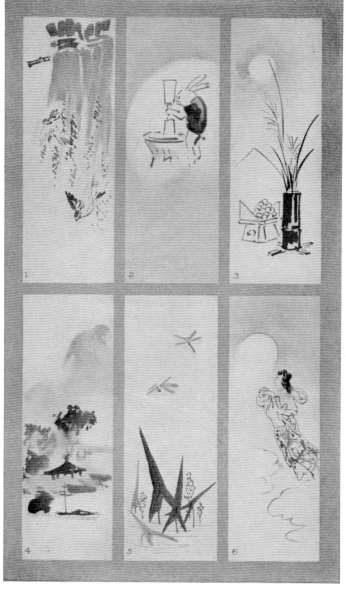

PLATE LXI

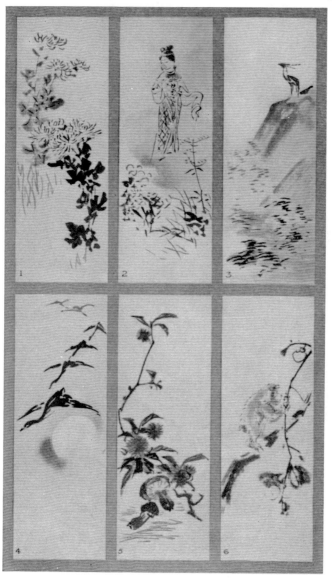

Plate LXII

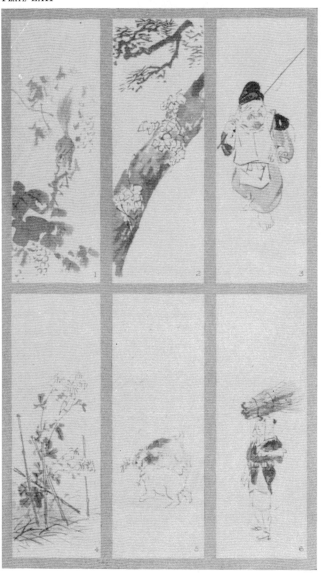

Plate LXIII

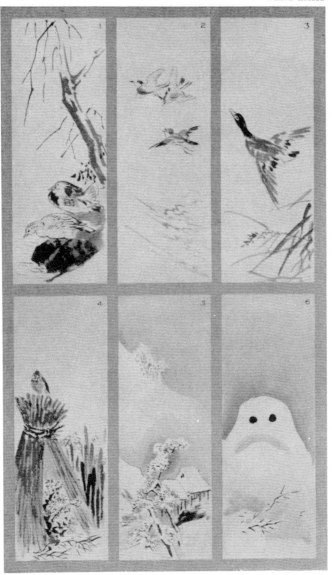

PLATE LXIV

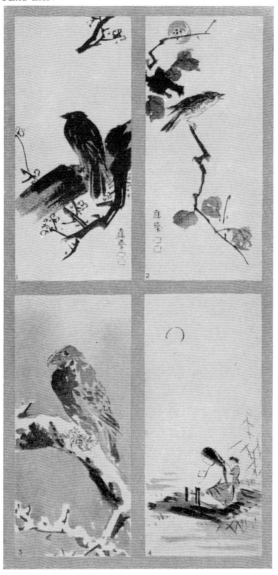

PLATE LXV

PLATE LXVI

EXPLANATION OF HEAD-BANDS

DESIGN OF TITLE PAGE. Butterflies and birds, known as *cho tori.*

CHAPTER ONE. The flower and leaves of the peony (BOTAN), as conventionalized on ancient armor (*yoroi*).

CHAPTER TWO. Fan-shaped leaves of the *icho* or GIN NAN (*Salisburiana*), placed in books in China and Japan to prevent the ravages of the bookworm.

CHAPTER THREE. The design called "Dew on the Grass and Butterflies" (*tsuyu, kusa ni cho*).

CHAPTER FOUR. The pattern (MOYO) known as bamboo and the swelling sparrow (*take ni fukura susume*). The parts of the bird are amusingly conventionalized—in the Korin manner. The word FUKURA written in Chinese contains the lucky character FUKU (happiness).

CHAPTER FIVE. Maple leaves are associated with Ten Jin (Sugiwara Michizane), patron of learning. Children in invoking his aid in a little prayer count the points of the maple leaf, saying, "*yoku te agaru*"—assist us to be clever. In Japanese the maple leaf is called *kaide,* meaning frog's hand.

CHAPTER SIX. The chrysanthemum pattern.

CHAPTER SEVEN. The water-fowl design, called *midzu tori.*

INDEX

[111]

INDEX

INDEX

[114]

INDEX

INDEX